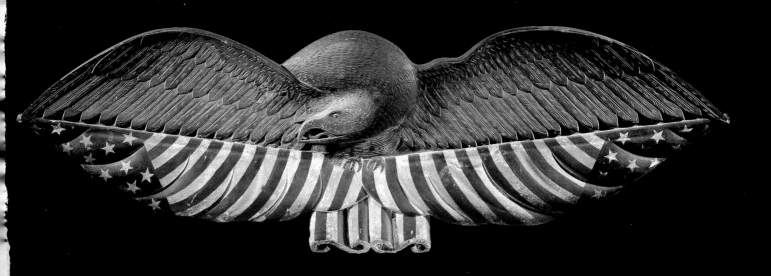

AMERICAN
EXPRESSIONS
OF LIBERTY

ART OF THE PEOPLE · BY THE PEOPLE · FOR THE PEOPLE

MINGEI INTERNATIONAL MUSEUM
IN ASSOCIATION WITH HARRY N. ABRAMS, INC., PUBLISHERS

AMERICAN EXPRESSIONS OF LIBERTY

ART OF THE PEOPLE · BY THE PEOPLE · FOR THE PEOPLE

MINGEI INTERNATIONAL MUSEUM'S

INAUGURAL EXHIBITION FOR ITS NEW FACILITY

CENTRAL PLAZA · BALBOA PARK · SAN DIEGO, CA

THIS BOOK IS MADE POSSIBLE BY

ROGER C. CORNELL

+

REVOLVING PUBLICATION FUNDS OF

SEYMOUR E. CLONICK

SYDNEY MARTIN ROTH

(FRONTISPIECE) EAGLE, J.T. LOTHROP ME LAST QUARTER 19TH CENTURY CARVED PINE WITH ORIGINAL POLYCHROME 14$^7/_8$ x 48$^1/_4$"

(OPPOSITE) UNCLE SAM TRADE STIMULATOR, MECHANICAL ADVERTISING CO. BOSTON, MA LATE 19TH CENTURY POLYCHROMED WOOD, METAL, WOOL 32 x 13$^3/_8$ x 13$^3/_8$" PHOTOGRAPH COURTESY OF WALTERS BENISEK ART & ANTIQUES

BOTH OBJECTS, COLLECTION MICHAEL DEL CASTELLO

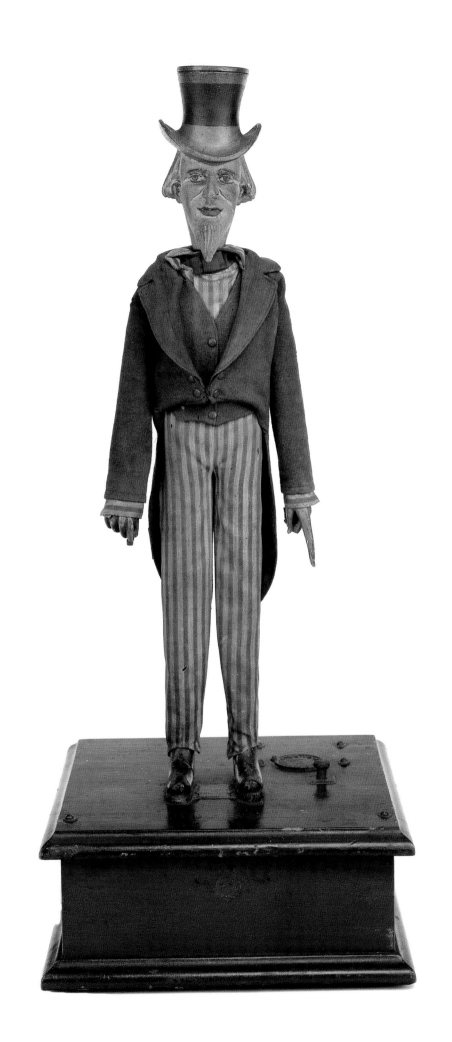

Lenders to the Exhibition

MUSEUM OF AMERICAN FOLK ART, NEW YORK

AMERICA HURRAH ANTIQUES, NEW YORK

HIRSCHL & ADLER GALLERIES, NEW YORK

FREELS COLLECTION, AMERICAN CAROUSEL MUSEUM, SAN FRANCISCO

MR AND MRS. WARREN BEACH

MICHAEL DEL CASTELLO

MARION W. AND WILLIAM H. DENTZEL, II AND FAMILY

DR. AND MRS. JOHN HOWARD

JASPER JOHNS

CODY PEARSON

MARGARET AND BILL PEARSON

MINDY PRESSMAN

SHELLEY PRESSMAN

GLENN AND LINDA SMITH

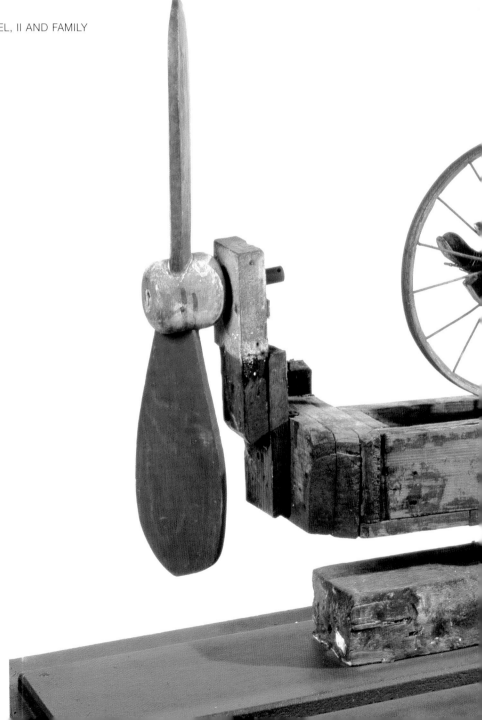

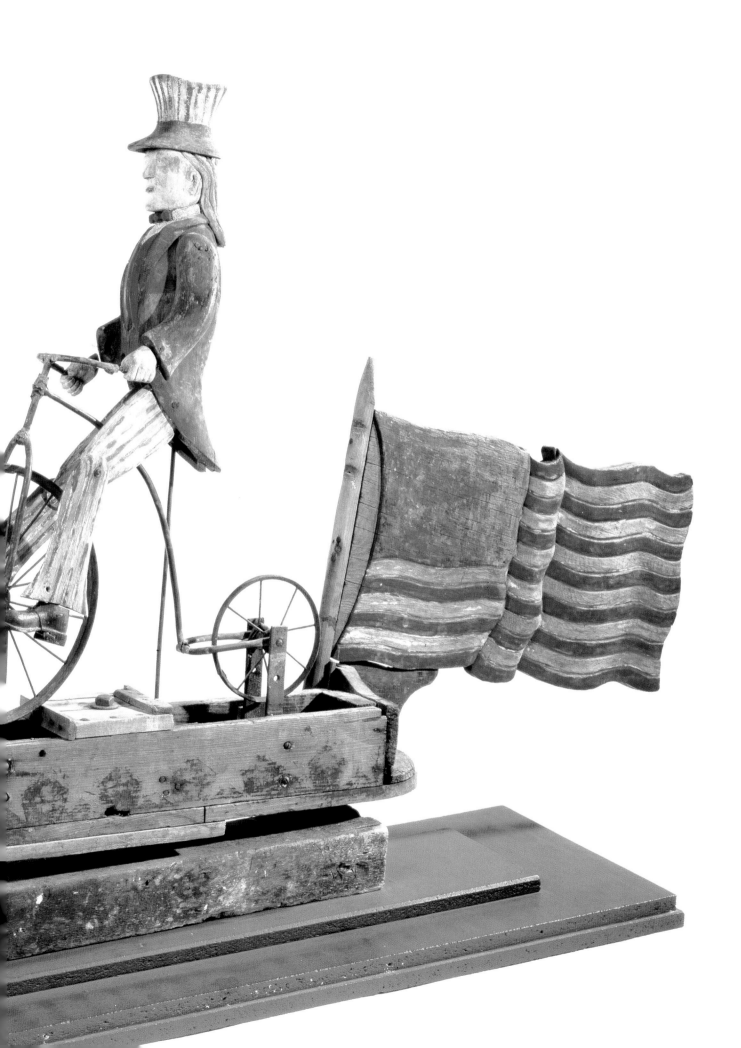

DEDICATED TO

JEAN HAHN

All who know her know why

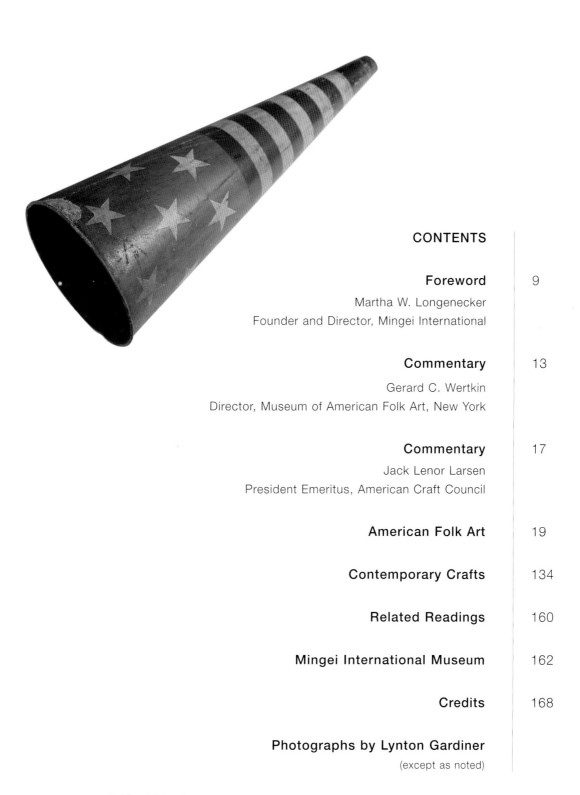

CONTENTS

Photographs by Lynton Gardiner
(except as noted)

FLAG MEGAPHONE Artist unknown Early 20th century Painted metal 30 x 15″
Gift of Bruce Lacont 1983.2.1

(PAGE 4) WHIRLIGIG: UNCLE SAM RIDING A BICYCLE Artist Unknown Probably
New York State, 1880–1920 Carved and Polychromed wood, metal 37 x 55½ x 11″
Promised bequest of Dorothy and Leo Rabkin P2.1981.6 Photograph by John Parnell

Objects above, Collection, Museum of American Folk Art, New York

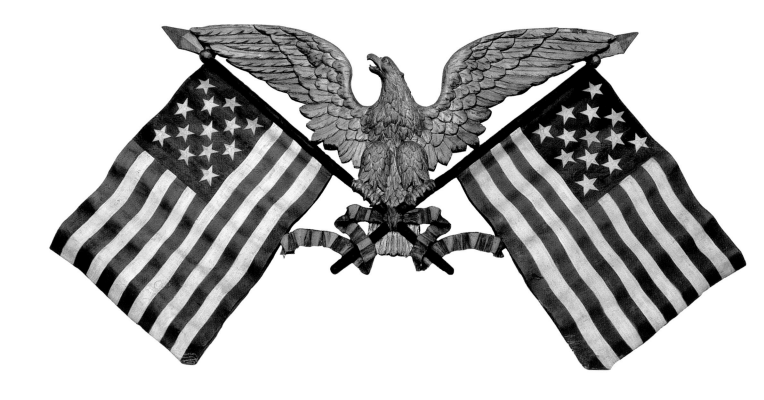

EAGLE WITH CROSSED FLAGS

Artist unknown
C. 1890
Polychromed and gilded carving from one piece of wood
35½ x 71⅜"

Collection, Michael Del Castello

Foreword

Martha W. Longenecker

Founder and Director — Mingei International Museum

O say, can you see, by the dawn's early light

What so proudly we hailed at the twilight's last gleaming?

Whose broad stripes and bright stars thro' the perilous fight,

O'er the ramparts we watched, were so gallantly streaming?

And the rockets' red glare, the bombs bursting in air

Gave proof thro' the night that our flag was still there.

O say, does that star-spangled banner yet wave

O'er the land of the free and the home of the brave?

"The Star-Spangled Banner"

The words and music of America's official patriotic anthem, like the folk arts in this book, express the yearning of a people to be free.

This documentary exhibition publication, *AMERICAN EXPRESSIONS OF LIBERTY—Art of the People, by the People, for the People* reflects the continuity of creativity and Yankee ingenuity beginning with early American folk art and continuing through contemporary crafts. All the objects are emblematic of the land and the people — many featuring beloved icons: the Stars and Stripes, Miss Liberty, Uncle Sam, and the American bald eagle. They express the need of every individual to be physically and psychologically free to actualize his own innate, creative potential.

Some of the most beautiful and powerful of these expressions born of America are black spirituals and American jazz. They arose from a people who, though in bondage, were free in spirit and rejoiced in the glory of creation. The deep conviction and timeless quality of this music continues to inspire and uplift people throughout the world.

The power and energy bursting forth in what we call art of the people can profoundly touch the core of being and awaken inner

sources of creativity. The beauty of these arts seems to be the flowering of an order and state of mind beyond the physical, and often beyond the restraints of physical circumstances. How moving and life-changing is the realization that the exquisite violin to be seen on page 91 was created by a prisoner using the only material he had—matchsticks!

The objects represented in this book were made in America over a span of fewer than 200 years and were created to fulfill needs of daily life. They include quilts, coverlets, weathervanes, trade signs, furniture, as well as whirligigs – objects of whimsy and play.

Not intellectually but intuitively conceived folk arts of all cultures speak eloquently of distinctive lands and peoples. They are intense and intimate expressions of human qualities — strength, humility, courage, resourcefulness, inventiveness, and a sense of humor. All are simply revealed in line, form and color; the international language of art that knows no barrier of time, place or race.

The settlers of the new American homeland brought with them little material wealth but a heritage of intangible riches: knowledge, skills, faith, joyfulness, and perseverance. They produced lively and enduring arts expressive of the distinctive American spirit. Long after many of these arts have outlasted their original use, they are cherished as heirlooms of timeless beauty.

If I say, "This is a fascinating time, explosive with new information, technology, understanding, and opportunities," would I be speaking of our late twentieth century? Could not such a description properly refer to any period since the establishment of this first republic based on the inalienable rights of life, liberty and the pursuit of happiness? The quilts, paintings and all the arts seen here are a dynamic source for seeing and understanding the strength and vigor of an ever-changing, emerging America. One simply has to look.

To survive in their new homeland, immigrants to America and their descendants for more than 200 years have been challenged to

develop a true understanding of the land and its resources. Native Americans, who had lived here for many centuries prior to the pioneers, were sensitively and maturely related to the land, the water, the air and all the elements of the cosmos. Theirs is an ancient heritage of profound beauty and power unsurpassed.

America's multicultural arts of the people today arise from vast urban as well as rural areas. Many are made by individuals who, seeking freedom of expression and creativity, were attracted to this land of opportunity. Thus, these contemporary crafts, are in their every essence, freedom of expression. Like the traditional folk arts which are the distillation of their time and culture, contemporary crafts reflect the incredible diversity of modern American life. Even in these highly industrialized times human beings have not outgrown the love and need for beautifully crafted, handmade objects: woven and printed textiles; vessels of clay, glass and wood; imaginatively designed furniture and jewelry. In fact, the more pervasive the machine in our lives, the stronger the hunger seems to be for objects made by human hands.

Today's expanding number of artists making objects for daily use in all media are challenged by the wealth of information and technology. Increased freedom of opportunity necessitates choice and focus in order for an individual to break through material and technique with an honest expression of enduring value. The contemporary crafts shown here from Mingei International Museum's permanent collection are classic examples of the work of leading artists who have focused their lives on their chosen crafts.

In pre-industrial times these arts of the people, by the people, and for the people were out of necessity handmade from limited materials (quilts often used recycled textiles). The machine freed the craftsman from the necessity of creating by hand. Today's designer-craftsmen create by choice and from a wealth of materials, realizing the timeless need for making and using objects that are the unfragmented expressions of head, heart and hands. Their creations are the heirlooms of the future.

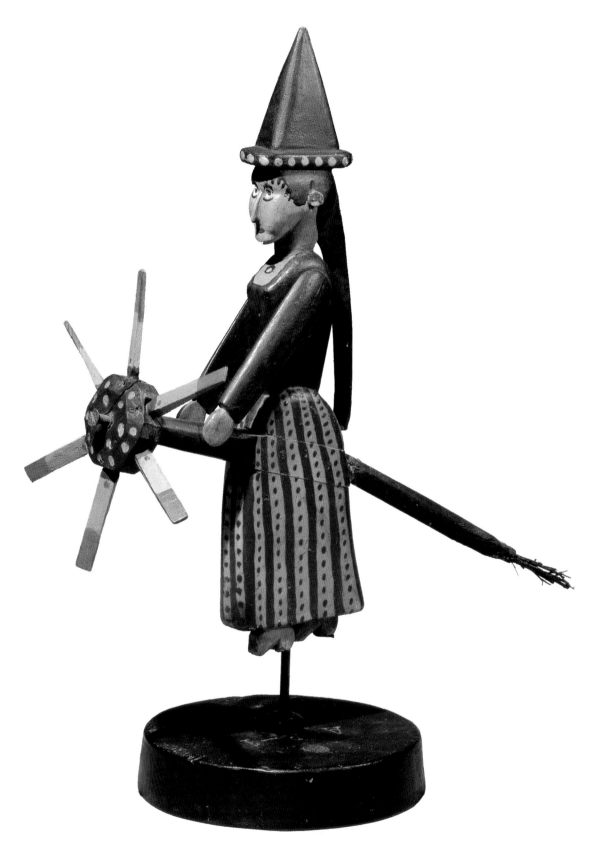

WHIRLIGIG: WITCH ON A BROOMSTICK Artist unknown New England, 1860–1880
Polychromed wood, twigs, metal 12¼ x 12¼ x 5¼"

Collection, Museum of American Folk Art, New York Gift of Dorothy and Leo Rabkin
1987.13.1 Photograph by Helga Studios

Expressions of Liberty in American Folk Art

Gerard C. Wertkin, Director
Museum of American Folk Art, New York

At first glance, the great figure of "Uncle Sam Riding a Bicycle" that adorns the cover of this catalogue appears to be fanciful, a product of its maker's whimsy and playfulness. There is an exuberant, celebratory spirit about this Uncle Sam on wheels that, if anything, is enhanced when the articulated figure is in motion. A second look, however, suggests the presence of something more: an engaging earnestness, a certainty of direction, even a seriousness of purpose, as America (joined, perhaps, by its northern neighbor, for the flag of Canada flies here too) pedals resolutely and without self-doubt into its future.

The identity of the maker of "Uncle Sam Riding a Bicycle" is unknown, but he brought to this hundred-year-old work of art a sure sense of Yankee rectitude, an anything-is-possible optimism and an uncritical belief in the promise of America. It is these qualities no less than the creative gifts and technical virtuosity of the artist that render "Uncle Sam Riding a Bicycle" such an apt symbol for an exhibition that celebrates the American spirit. As Director of the Museum of American Folk Art, I am delighted that this wonderful object, a promised bequest to the Museum from Dorothy and Leo Rabkin, should have been chosen by Mingei International Museum of Folk Art as the signature-piece for the exhibition that inaugurates its splendid new home.

American folk art does appear to be an especially appropriate vehicle to give voice to the theme of this publication and the exhibition that it documents: *AMERICAN EXPRESSIONS OF LIBERTY — Art of the People, by the People, for the People.* Like "Uncle Sam Riding a Bicycle," many of the other great masterworks of American folk art draw upon ideas of patriotism, national pride and American history for their inspiration. But there is also an

irony in the choice of folk art to represent expressions of liberty. Although the field developed in America in the 1920's and 1930's independently of the earlier European interest in the subject, European ideas about folk art continue to affect American thinking in the field. In Europe, folk art is a class-based concept, referring invariably to the tradition-bound household crafts of peasant communities. According to this view, the decorative patterns and practices of *Volkskunst* are transmitted through successive generations within closed groups related by kinship, common agrarian lifestyle and religious faith. There is very little that speaks of "liberty" in this approach to the subject. American folk art, on the contrary, exists within far more generous and embracing boundaries.

Through much of American history, gifted artisans and amateurs have created objects of utility, household decoration or personal fancy that are now characterized as works of American folk art by virtue of their individuality of expressive voice; beauty of form or composition or decoration; and technical excellence. These works of art may derive ultimately from community traditions or shared ideas, but more often than not they are notable for their freedom from strict conventions or received forms. Indeed, with the exception of relatively closed communities like the Amish, the social conditions that supported the creation of folk art in Europe have never existed in the United States. Little wonder then that American folk art should take on such startling new forms.

Freedom of expression is a hallmark of American folk art. Consider, for example, "Musician with Lute," part of a remarkable water-powered assemblage that was created at the turn of the last century by Clark W. Coe, a Killingworth, Connecticut farmer and basketmaker. According to local tradition, Coe built the movable figures for his grandchildren, but they are no less striking in their originality or appealing in their artfulness. It is unlikely that there was anything like them in Killingworth or elsewhere, although the animals and other figures portrayed by Coe, includ-

ing the "Musician," may have been familiar to the rural environment. The other vigorous sculptural forms that are included in this exhibition are also individualistic interpretations of familiar themes: a gatepost ornament in the form of a penguin; an anthropomorphic yarn reel; a whirligig of a witch on a broomstick. Indeed, freedom of expression is evident throughout the exhibition, whatever the medium or period.

The field of American folk art has been receptive to the work of twentieth-century self-taught artists as well as to the earlier work. The mavericks of the art world, self-taught painters and sculptors generally are unaffected by artistic trends or movements, creating highly personal works of art that rarely acknowledge either established or emerging traditions in art history. *AMERICAN EXPRESSIONS OF LIBERTY* highlights the works of several widely recognized self-taught artists: Eddie Arning; David Butler; Josephus Farmer; Howard Finster; John Perates; Elijah Pierce; and others. If American folk art is distinguished by its freedom of expression, it is also characterized by diversity. Without detracting from their individual, expressive lexicons, each of these artists draws upon the well springs of cultural history in their work: Finster, for example, from Southern evangelical religion; Perates from a fusion of Byzantine iconography and New England traditional design; Farmer and Pierce from their heritage as African Americans.

Because of the broad range of artistic expressions represented in the field of American folk art, its assumptions have been challenged. The first generation of collectors, who gave shape to the field in the 1920's, rarely articulated a clear or consistent approach to the objects that they collected. The most prominent of them were themselves artists; they were more interested in seeking out in the earlier vernacular traditions of America a paradigm for a new American art. For these modernists, working in the aftermath of the 1913 Armory Show, it was the formal aesthetic qualities of the objects that they called "folk art" that most

interested them. By and large, however, the objects themselves and the circumstances of their creation were little understood.

As more became known about the richly gifted artisans and amateurs who produced works that previously were seen as anonymous, the full diversity of the contexts in which they created, their widely varied sources and techniques, the disparate methods of transmission and training and the differing community traditions that they represented, the very notion of American folk art as a coherent field was questioned. A highly charged, occasionally rancorous, literature developed by mid-century over issues of classification and terminology, some theorists holding to the more limited, class-based European definition of folk art.

Notwithstanding the raging of these debates, the proponents of American folk art continued to study, collect and exhibit the objects comprising the field, however arbitrary the classification sometimes appeared, confident that these objects deserved the consideration given to mainstream art. As an increasingly reliable body of information was developed, it became clear that the field, however diverse and elusive its definitions, had shed light on a highly important aspect of the American heritage and warranted the serious consideration of scholars.

Mingei International Museum of Folk Art, through exhibitions like *AMERICAN EXPRESSIONS OF LIBERTY*, will help broaden the growing understanding of folk art not only in the scholarly community but among members of the general public, as well. At its best, folk art tells us something about ourselves. It speaks to our common heritage as Americans as well as to the freedoms that are basic to our self-definition if not always to the unfortunate realities of our history. Folk art in America continues to evolve with the changing composition of the American people. But even as it changes, it has its roots in our past. Its study is essential to a full appreciation of the promise of America.

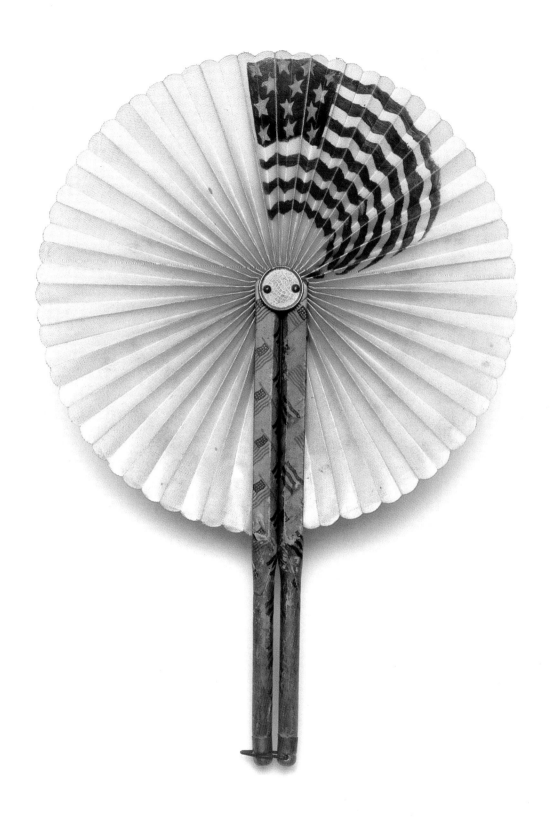

Ceremonial Fan Artist unknown 1902 Linen with stenciled design, wood, paper, metal
12½ x 8⅝″ (open) Collection, Jasper Johns

Possibly used at termination of U.S. military protection of Cuba, Havana, May 20, 1902.

Commentary

Jack Lenor Larsen, Hon. R.D.I., Hon. F.A.S.I.D.
President Emeritus, American Craft Council

The People, Yes! Yes, the People

Carl Sandburg

When I first visited Poland, for NYC's Museum of Modern Art in 1967, I asked their youthful ministers of culture why the preponderance of art commissioned for such public spaces as libraries and town halls was in tapestry or other wall hangings. As the government was then the only art buyer, the question seemed relevant. "Was it," I asked, "that hangings would be more removed than painting from political statements?" The response was "No, we have been trained in the West and are keen on all forms of modern art. But, as the works we commission are for public spaces, we feel they should appeal to the broadest number of people. We find even the maintenance staff feeling some relation to fiber, or to the perceptible craft of the structure, or ... 'my grandmother did something like that'."

The great Polish weaver, Magdelena Abakanowicz, explained that we are born into a world of cloth — cloth in our swaddling clothes, marriage vestments and shrouds, fiber in the grasses and trees around us. "We are fiber — our skin and hair, even our tissues and sinews are fiber."

I concluded that one could carry this over to other craft media; clay is of the earth, so are metals; glass is like water forever frozen. All people sense an affinity to objects in which materials and methods of making can be so readily perceived, understood, and appreciated. I came home with the feeling that art in public spaces need have a far broader appeal than for private offices or at home.

The three decades since have witnessed a flowering of craft in America. There are more makers, many more collectors, and more galleries and museums showing craft. Consider for a moment the explosion of media used. American craft at mid-century was either woven or thrown stoneware or silver jewelry. Since that time we have seen the introduction and mastery of glass in myriad forms, forged iron, porcelain and raku wares. Fiber now includes whole schools of paper and felt makers, a revival of basketry, quilting, and myriad cloth embellishments conveniently termed Surface Design or art-to-wear. Crafted furniture and turned wood have each attracted new generations of makers and collectors. We have, in addition, mixed media in many guises and crossovers between craft and fine arts.

At the same time, as interest in folk art and ethnographic expression grows unabated, our whole definition of art opens to seeing all human expressions and the multifarious skills of the world's peoples as something both wondrous and desirable. Whether perceiving them in exhibits or living with them at home, hand arts enrich our life experience, awaken senses and sensibilities, and reinforce our appreciation of the human urge to create.

How appropriate, then, that America is now opening a new museum sufficiently large as to embrace the whole of it. Congratulations to all those supporting this magnificent gift to the people, for the people — exhibiting art of the people. All of them.

Jack Lenor Larsen, a weaver and textile designer, is a scholar, author, and traveler. Many of his collections derive from a culture of a people; others have grown out of his involvement with new or old technologies. As designer extraordinaire and chairman of his own furnishings house, Jack Larsen stresses the need for ... "a brave new vision, and an evolving environmental design team, in which all of the design disciplines will contribute as a unit."

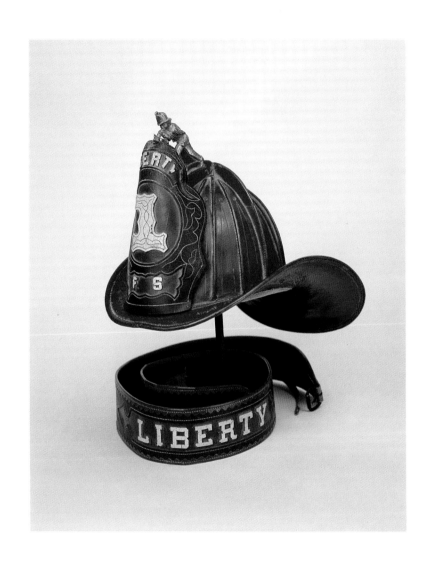

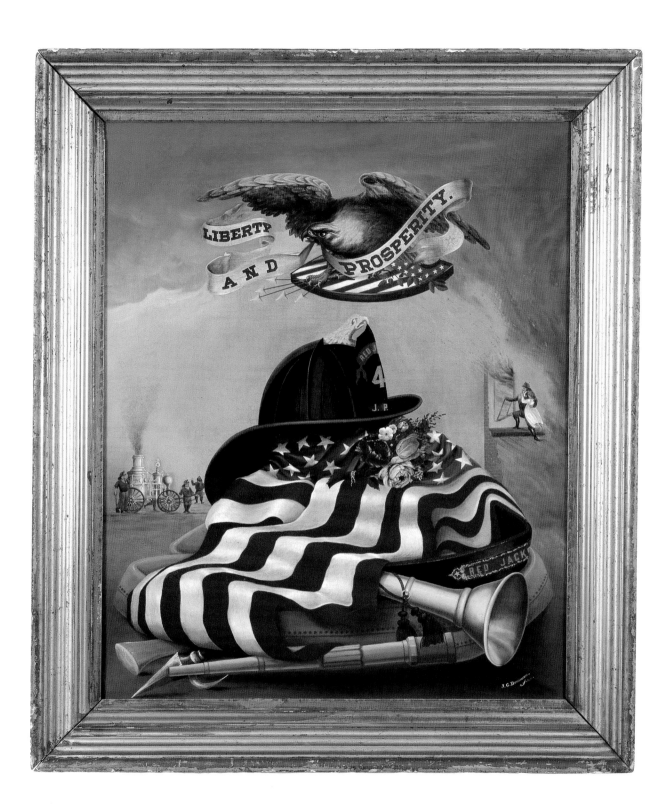

FIREMAN'S HAT AND BELT PAGE 20

Artist unknown
1870
Leather

Collection, Margaret and Bill Pearson
Photograph courtesy of David A. Schorsch, Inc.

FIREHOUSE MEMORIAL PAGE 21

J.G. Baumann
1870
Oil on canvas
$33\frac{1}{2}$ x 28″

Collection, Margaret and Bill Pearson
Photograph by Steve Jague
Courtesy of David A. Schorsch, Inc.

SENECA

James Bard (1815–1897)
New York, 1864
Oil on canvas
30 x $50\frac{3}{8}$″

Collection, Michael Del Castello

The Seneca is an American wooden, paddle-wheel steamer built at
East Albany in 1863. She was used for towing purposes. She became
unique among Hudson River vessels because she was chartered by the
New York City Police Department for service as a harbor vessel.

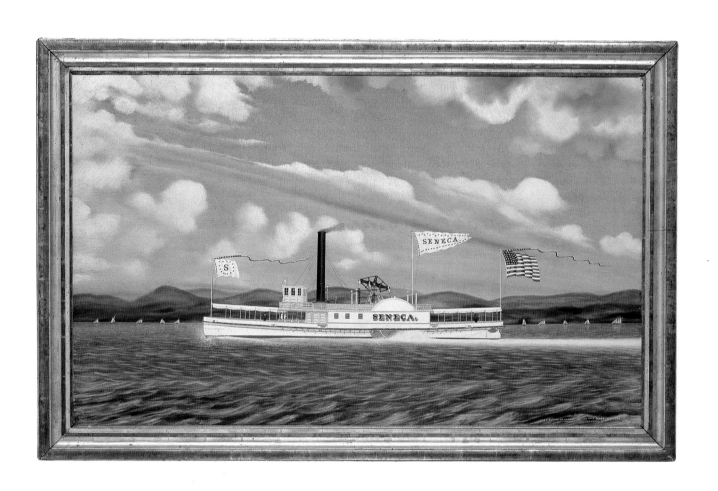

STILL LIFE

Isaac W. Nuttman
Newark, New Jersey, c. 1865
Oil on canvas
40¼ x 60″

Collection, Michael Del Castello

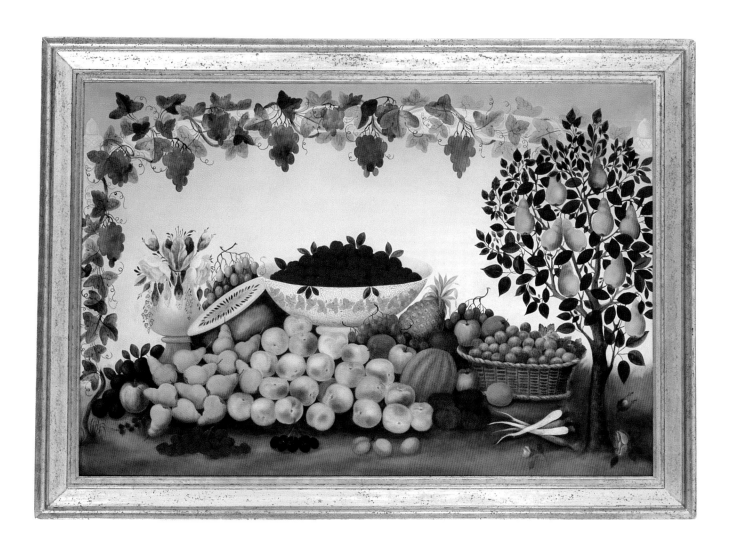

PORTRAIT OF JOSEPH BELTON (d. 1768)

Artist unknown
Southern Connecticut, c. 1703
Oil on pine panel
26½ x 18½"

Collection, Michael Del Castello

This is one of the earliest surviving, culturally significant, and most
aestethically powerful statements in American folk portralture. It is one
of five known paintings by this as yet unidentified hand. The use of the
export porcelain tea bowl and exotic birds illustrates not only the status
of the sitter but also the growing influence of oriental trade on the
colonies.

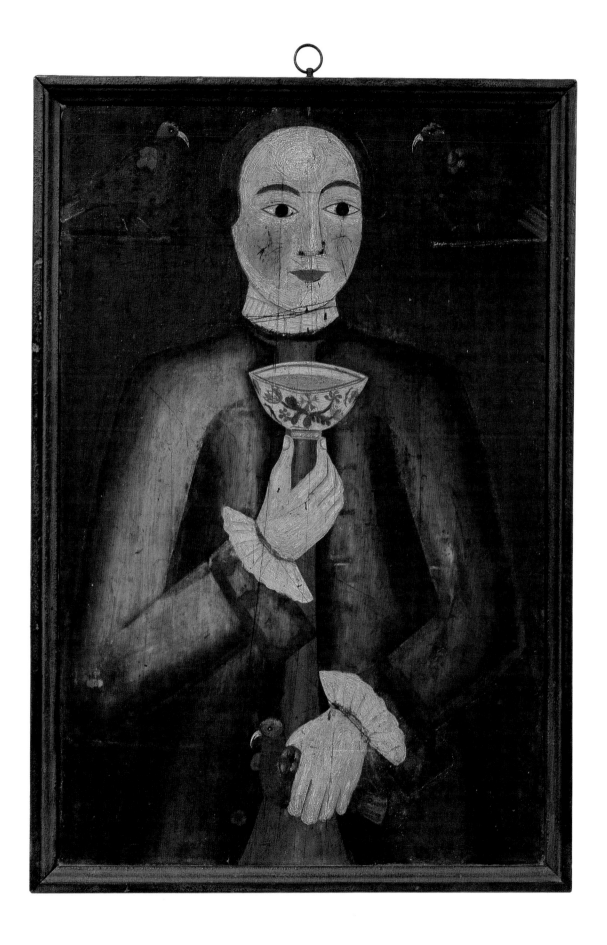

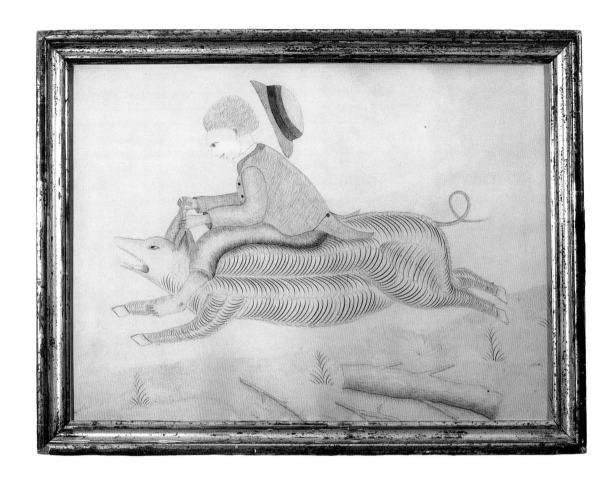

PORKY WITH RIDER UP

Attributed to S.H. Billman
C. 1875
Pen and ink calligraphic drawing on paper
16⅞ x 23⅛"

Private collection

BALD EAGLE AND ARROWS

S. Fagley
1872
Pen and ink on paper
9¾ x 11"

Collection, Museum of American Folk Art, New York
Gift of Dr. Lillian Malcove 1977.17.1

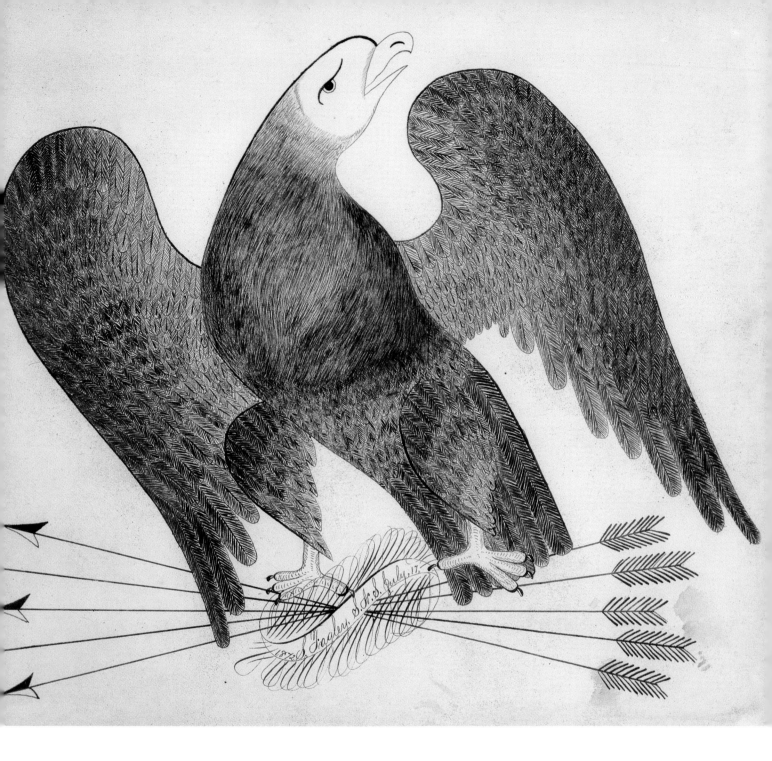

GENERAL GEORGE WASHINGTON ON HORSEBACK

Attributed to Henry Young (1792–1861)

Lycoming County, Pennsylvania, 1825–1835

Pen and ink, pencil, and watercolor, on wove paper

13⅝ x 9¾"

Collection, Museum of American Folk Art, New York
Gift of Ralph O. Esmerian 1993.10.1
Photograph by Helga Studios

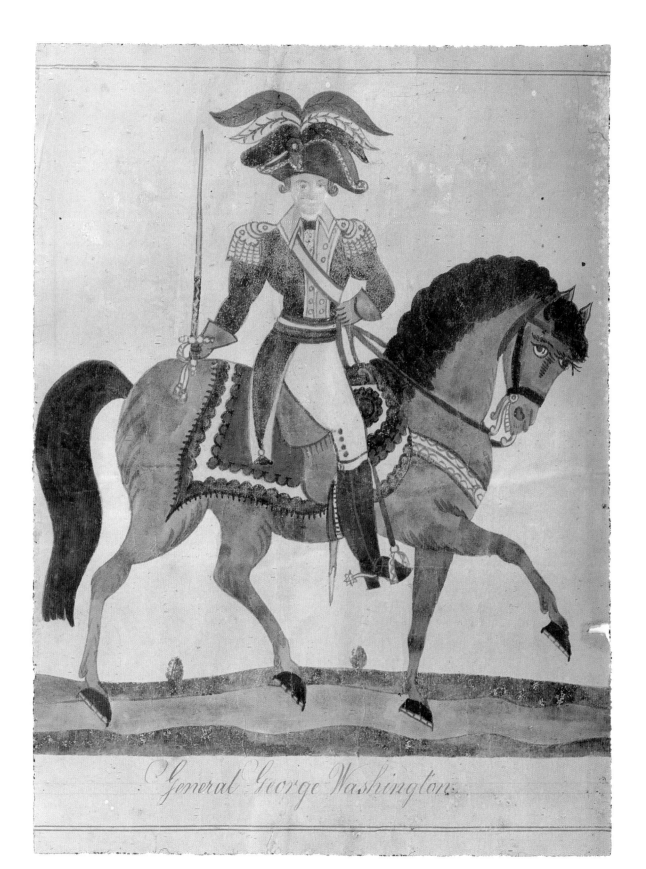

General George Washington

LIBERTY WEATHER VANE

Cushing & White
Waltham, Massachusetts, patented: September 12, 1865
Painted copper with traces of gilt
40¾ x 29¼ x 5¾"

Collection, Michael Del Castello

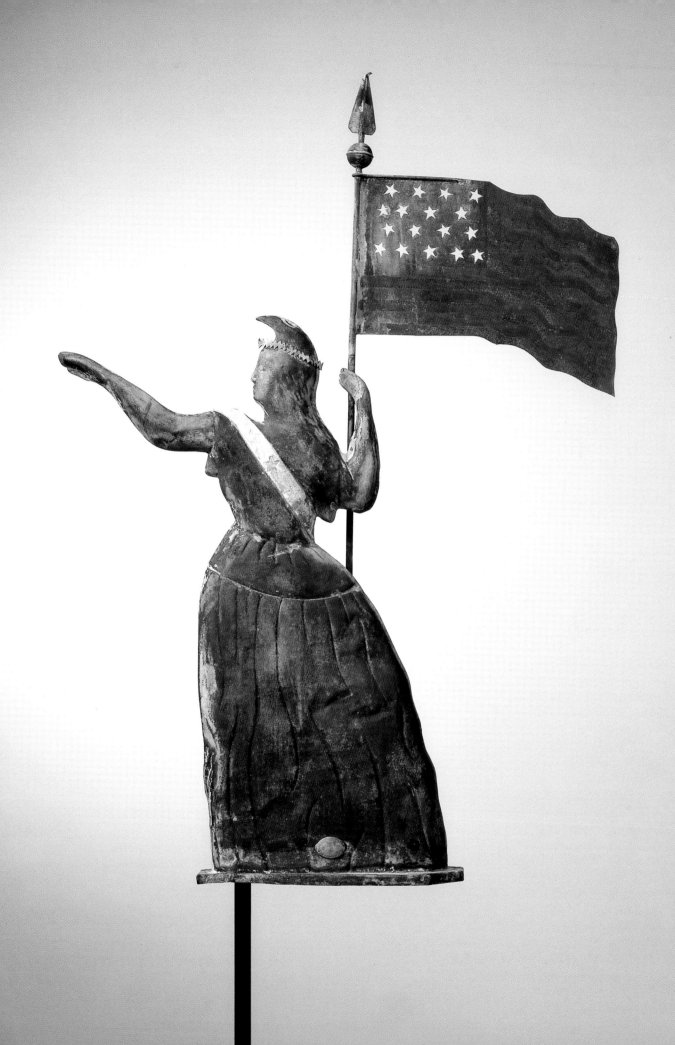

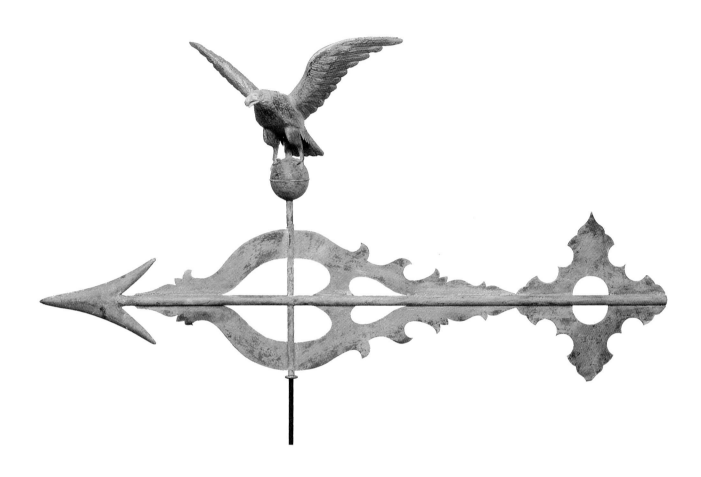

EAGLE WEATHER VANE

Artist unknown
19th century
Copper
25 x 48"

Collection, Margaret and Bill Pearson

BANNER WEATHER VANE

Artist unknown
19th century
Copper
36 x 36"Collection, Margaret and Bill Pearson

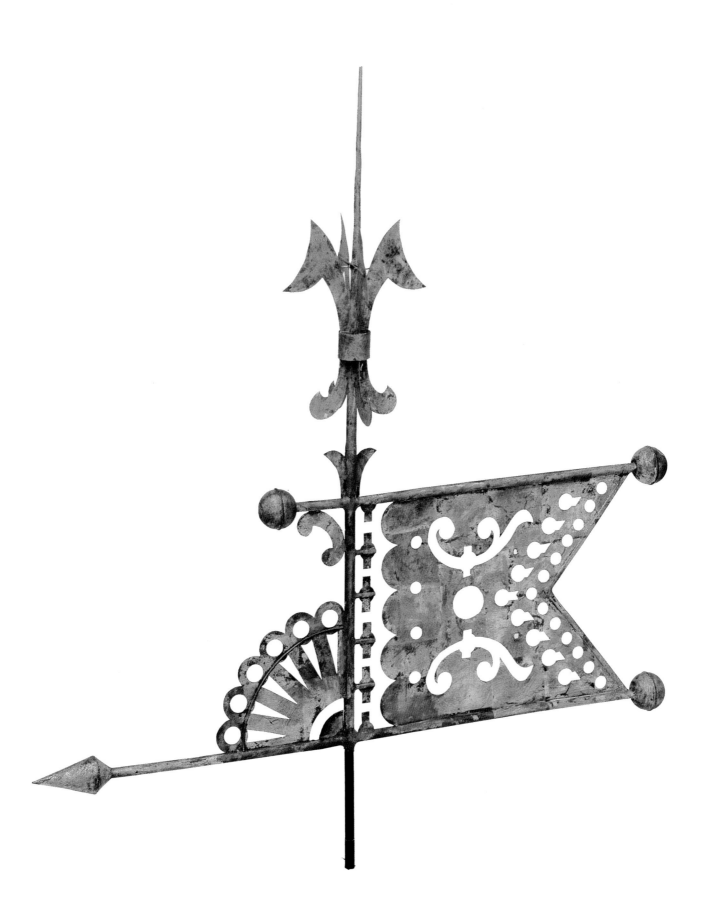

EAGLE WEATHER VANE

Artist unknown

From a shoe factory in Rockland, Massachusetts, 1825–1850

Copper with zinc head

27 x 38 x 15³/₁₆″

Collection, Michael Del Castello

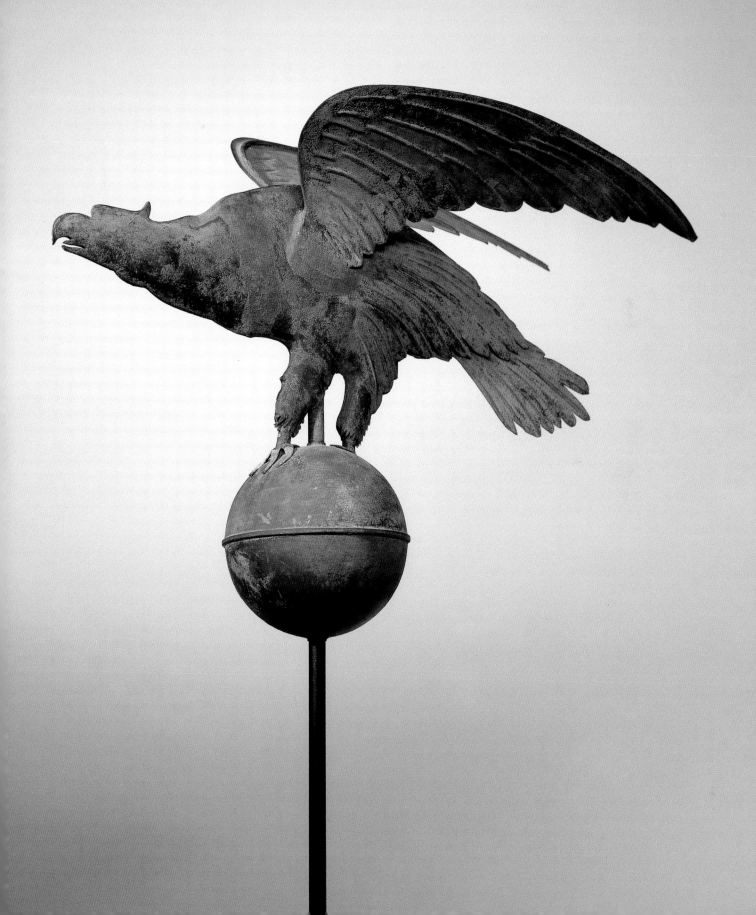

SCHOONER WEATHER VANE

Attributed to W.A. Snow
Boston, Massachusetts, c. 1896
Copper
52½ x 68⅝ x 6½"

Collection, Michael Del Castello

HUPMOBILE WEATHER VANE

PAGE 40

Probably E.G. Washburne & Co.
New York, c. 1910
Copper
31 x 38¾ x 13¾"

Collection, Michael Del Castello

A rare, three-dimensional depiction of the open touring car.

POLAND SPRINGS BLERIOT MONOPLANE WEATHER VANE

Artist unknown
PAGE 41
Maine, 1909
Copper
Plane: 10 x 57¼ x 55"
Directionals: 15¾ x 38⅝ x 38½"

Collection, Michael Del Castello

This one-of-a-kind vane decorated the top of The Poland Springs
House, one of the most popular of the famous nineteenth-century
spas. Tradition indicates that Louis Blériot, the first man to cross the
English Channel in a heavier-than-air machine, flew his monoplane to
America in 1909 and raced it at Portland and Poland Springs, Maine.
He was the victor in all events. Blériot's accomplishments delighted
everyone to such an extent that this vane was created to commemo-
rate his visit.

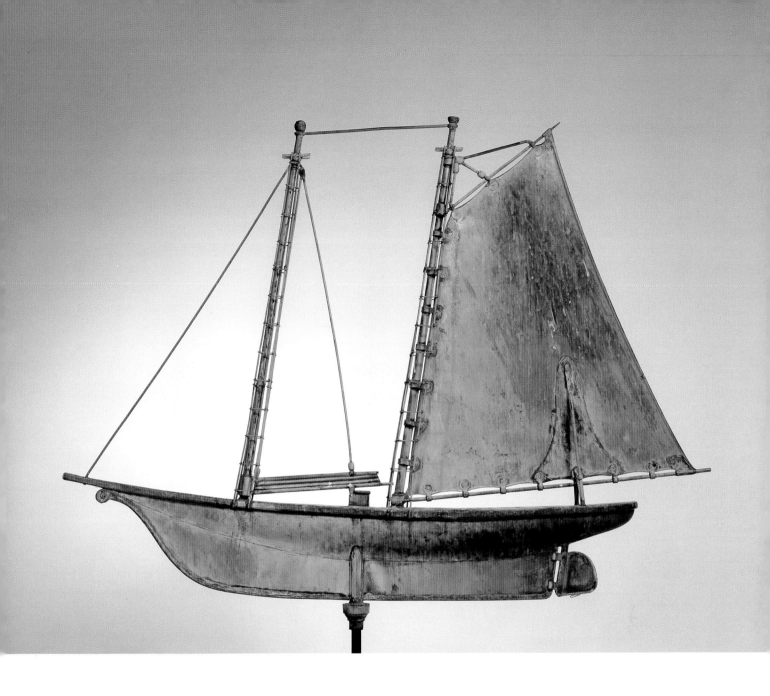

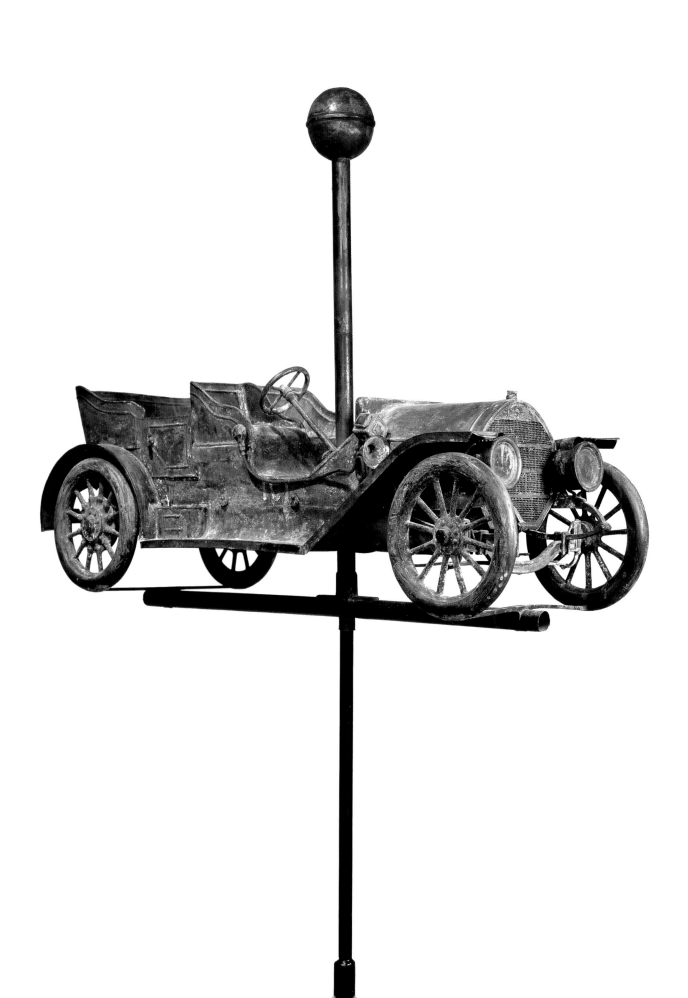

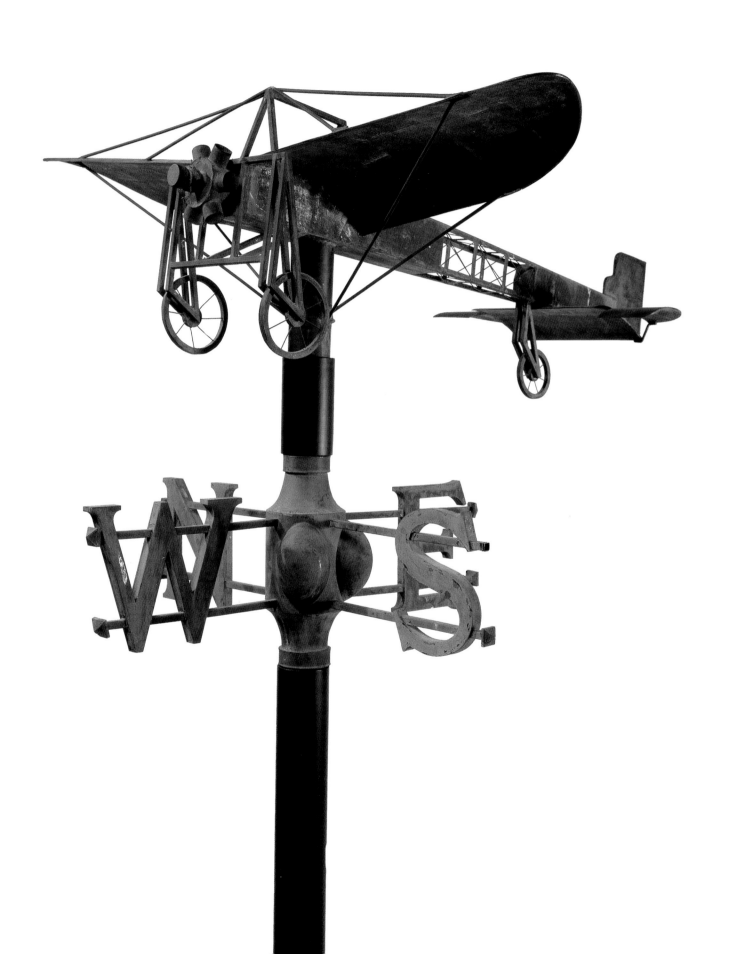

ROOSTER WEATHER VANE

Artist unknown
19th century
Molded copper
24 x 22"

Collection, Margaret and Bill Pearson

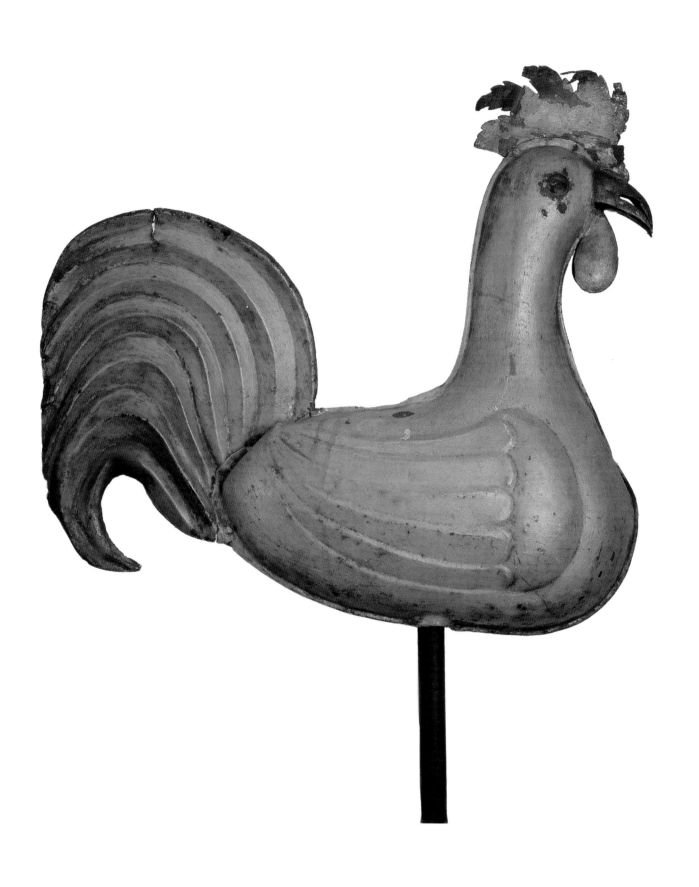

SETTER WEATHERVANE

Manufacturer unknown
Eastern United States, c. 1875
Metal
17½ x 3½ x 34″ long

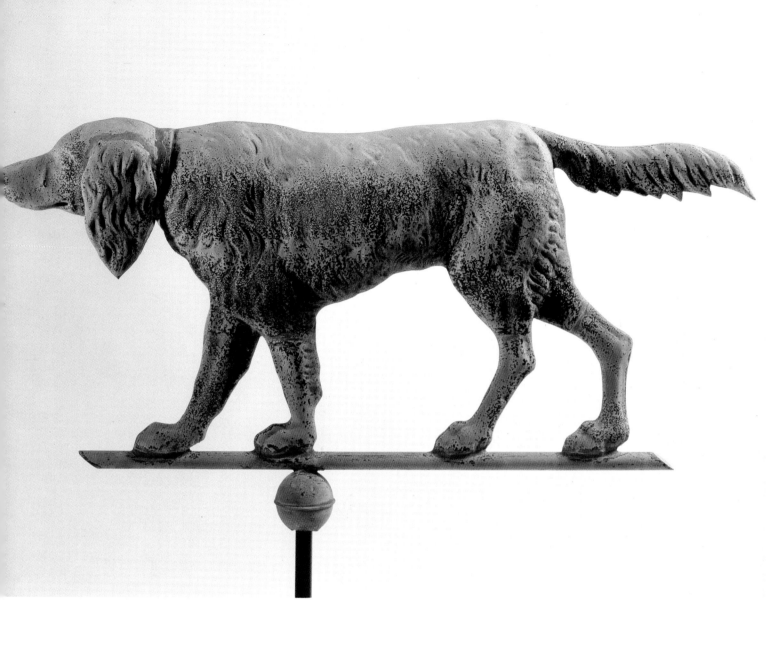

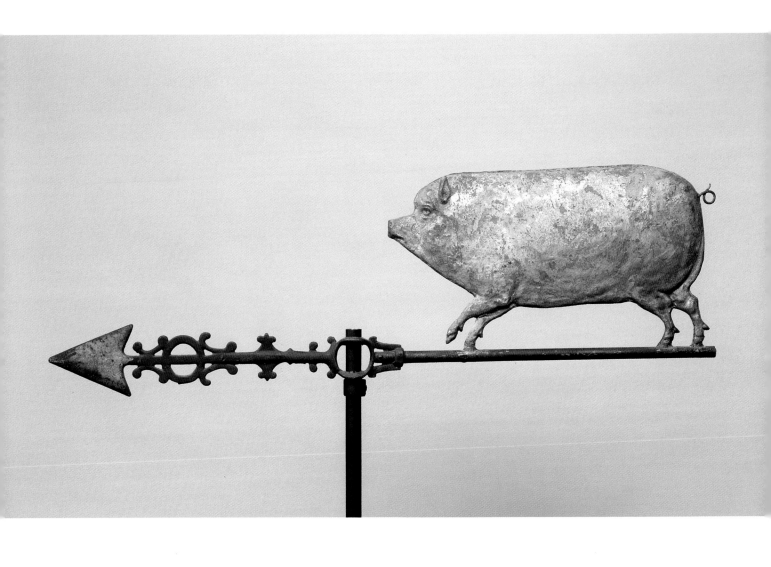

PIG WEATHER VANE

Artist unknown
19th century
Molded copper
8¼ x 29"

Collection, Margaret and Bill Pearson

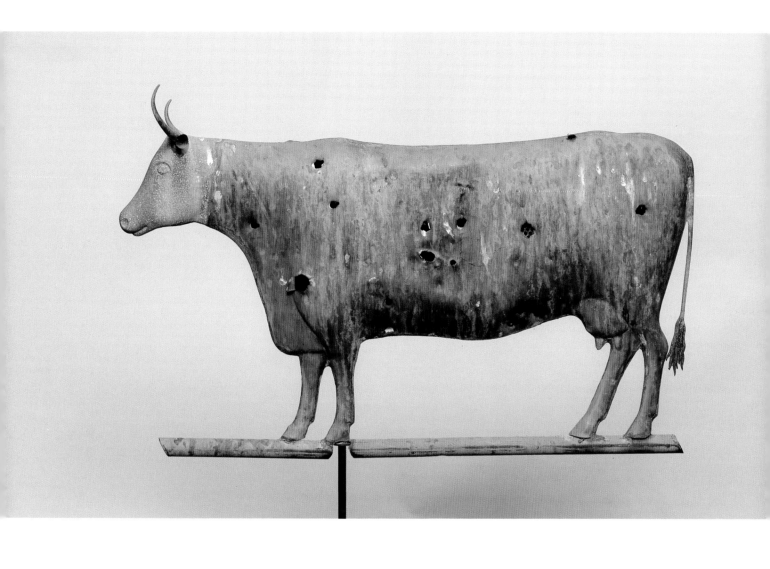

COW WEATHER VANE

A.J. Harris, 1868–1882
Molded copper
12 x 25″

Collection, Margaret and Bill Pearson

ROOSTER WEATHER VANE

Artist unknown
New England, 1800–1825
Carved and painted wood
37½ x 33¼ x 4⅞"

Collection, Michael Del Castello

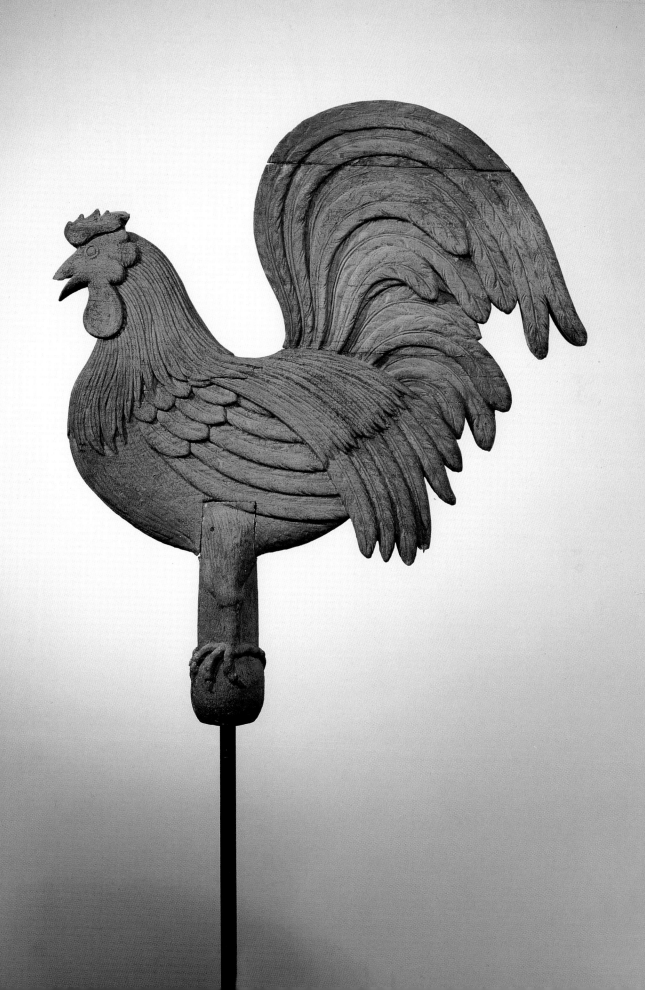

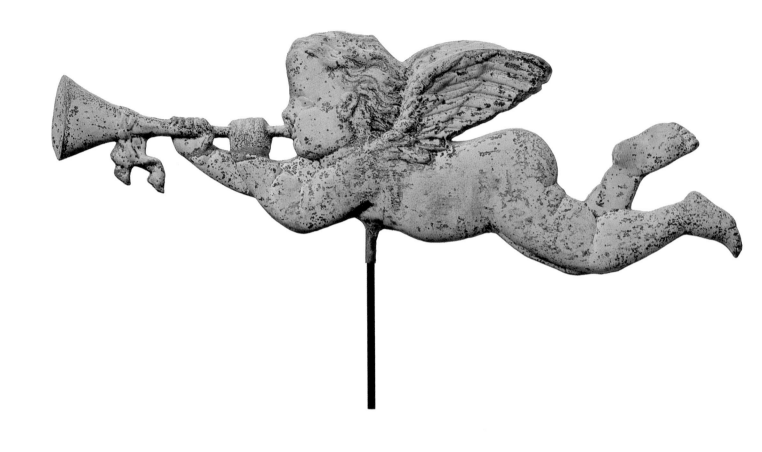

CHERUB WEATHERVANE

Cushing & White
Waltham, Massachusetts, c. 1869
Molded copper
10 x 35″

Private collection

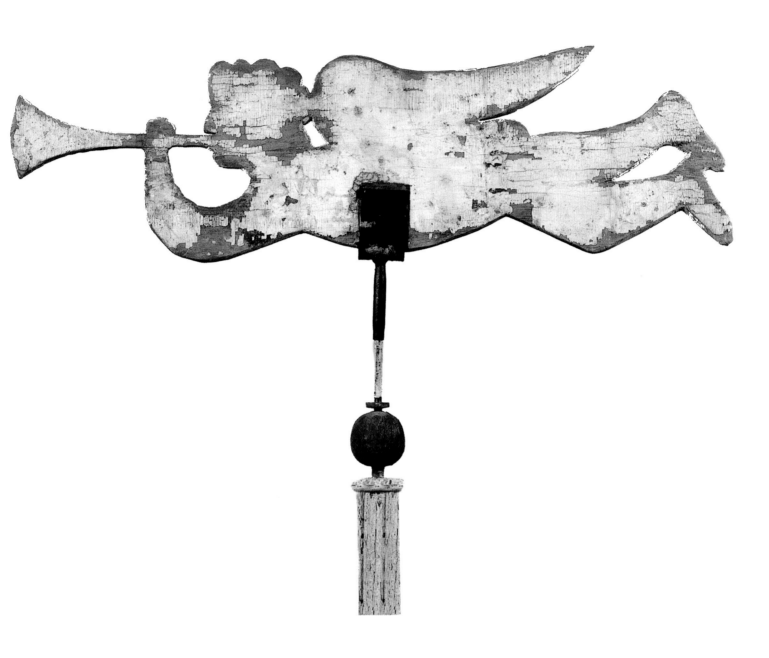

ANGEL GABRIEL WEATHER VANE

19th century
Painted wood
60 x 42"

Collection, Glenn and Linda Smith

HORSE AND SULKY WEATHER VANE

Probably "St. Tulian," Fiske & Co.
Late 19th century
Copper with gold leaf
24¾ x 41⅛ x 10¾"

Collection, Michael Del Castello

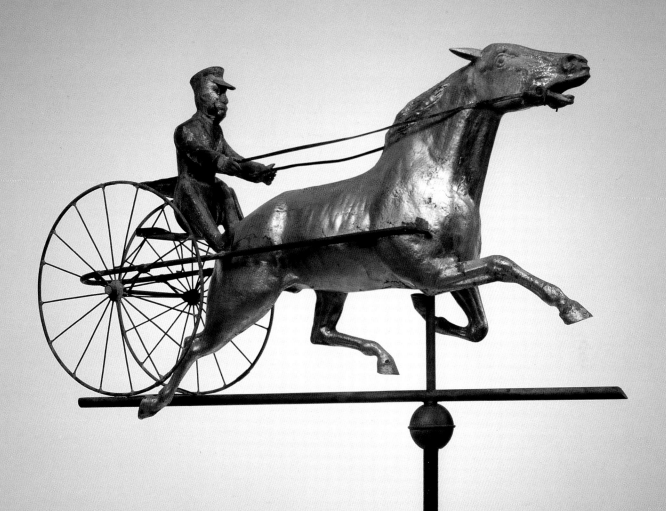

HORSE AND SULKY WEATHER VANE

J.L. Mott
19th century
30½ x 36½"

Collection, Margaret and Bill Pearson
Photograph by Steve Jague
Courtesy of David A. Schorsch, Inc.

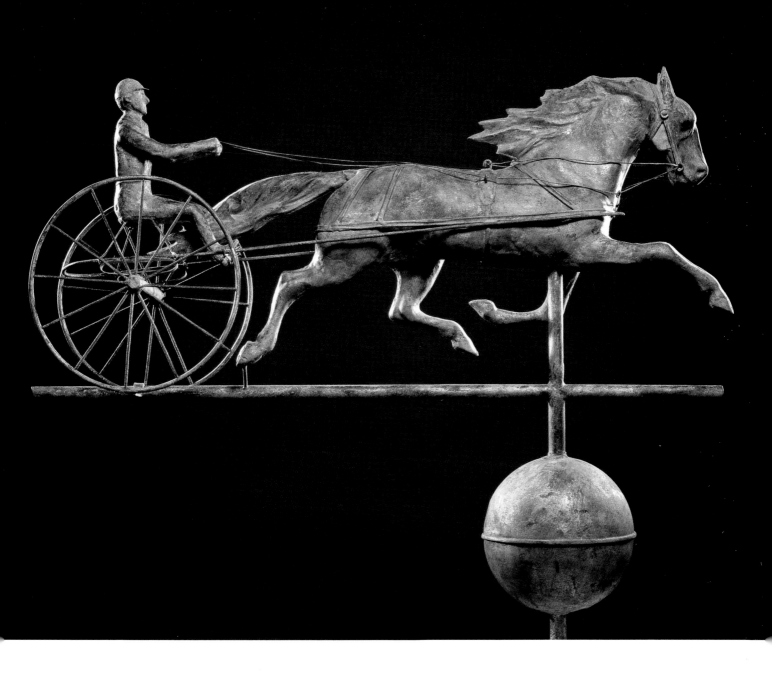

TRADE SIGN

1857
Leather, wool and cotton thread
15½ x 25¼"

Collection, Margaret and Bill Pearson
Photograph by Steve Jague
Courtesy of David A. Schorsch, Inc.

In 1851, Isaac M. Singer (1811–1863) began a company to manufac-
ture and sell a revolutionary product—a machine to automate and
assist in the making of clothing. Little did he realize that the newly
formed I.M. Singer and Company was destined to become the world
leader in the manufacture and distribution of sewing related products
and sewing machines. Singer himself enjoyed demonstrating his
machine to church and social groups, at country fairs and circuses. To
promote the convenience of the foot treadle—which left both the oper-
ator's hands free—salesmen gave demonstrations, creating stitched
pictures like this one, which served as James Farren's trade sign.

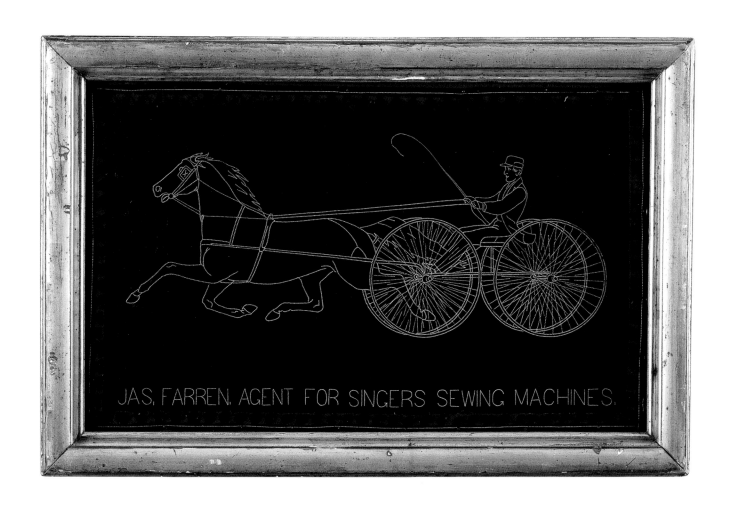

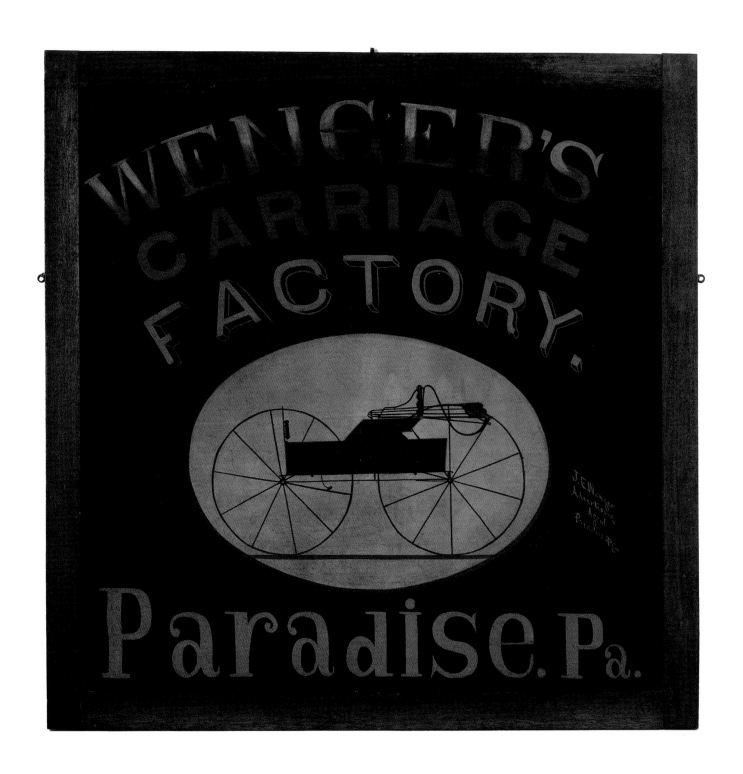

WENGER'S CARRIAGE FACTORY TRADE SIGN PAGE 58

J.E. Wenger
Paradise, Pennsylvania, c. 1880–90
Oil on canvas with wood frame
36 x 36"

Collection, Michael Del Castello

TAVERN SIGN PAGE 59

D. Baille
Scranton, Pennsylvania
Oil on wood
$55^{3}/_{16}$ x $43^{3}/_{8}$ x $2^{3}/_{8}$"

Collection, Michael Del Castello

TRADE SIGN OPPOSITE

Attributed to Rufus Porter (1792–1884)
Randolph, Vermont, c. 1820
Oil on pine panel
$21^{1}/_{2}$ x $52^{1}/_{2}$"

Private collection
Photograph courtesy of David A. Schorsch, Inc.

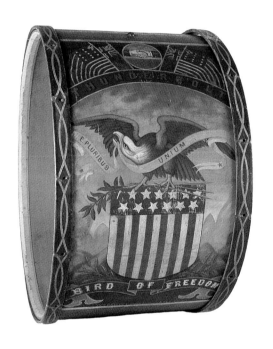

CIVIL WAR PARADE DRUM

William Bridget
Belfast, Maine
Polychromed wood
22³⁄₈ x 35³⁄₄″

Collection, Michael Del Castello

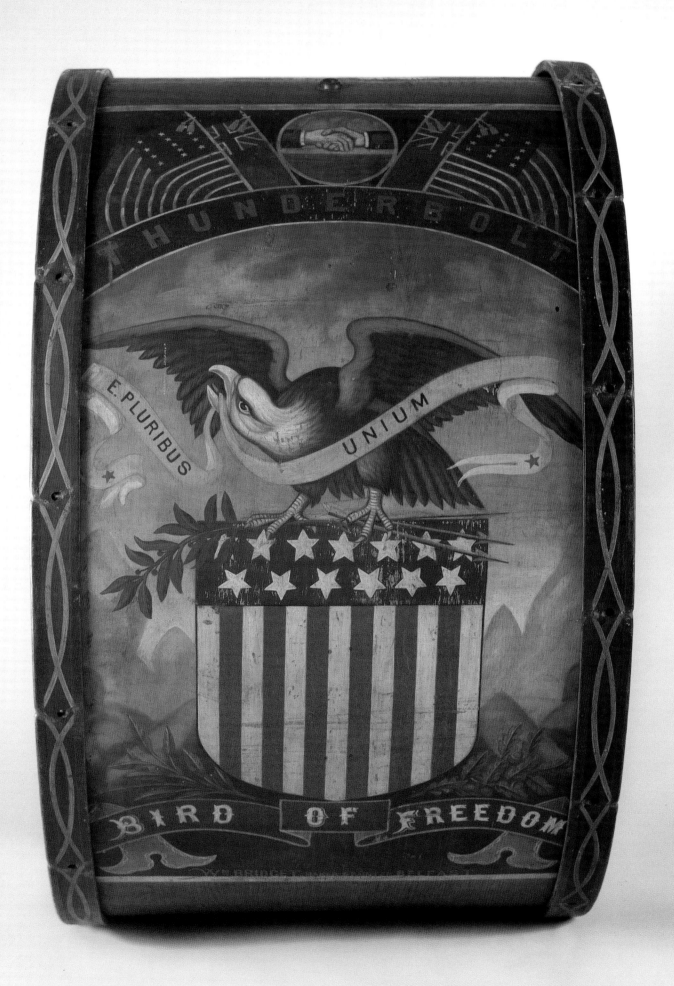

EAGLE ON SHIELD

Artist unknown
Polychromed wood
29¾ x 27⅜ x 9⅜"

Collection, Michael Del Castello

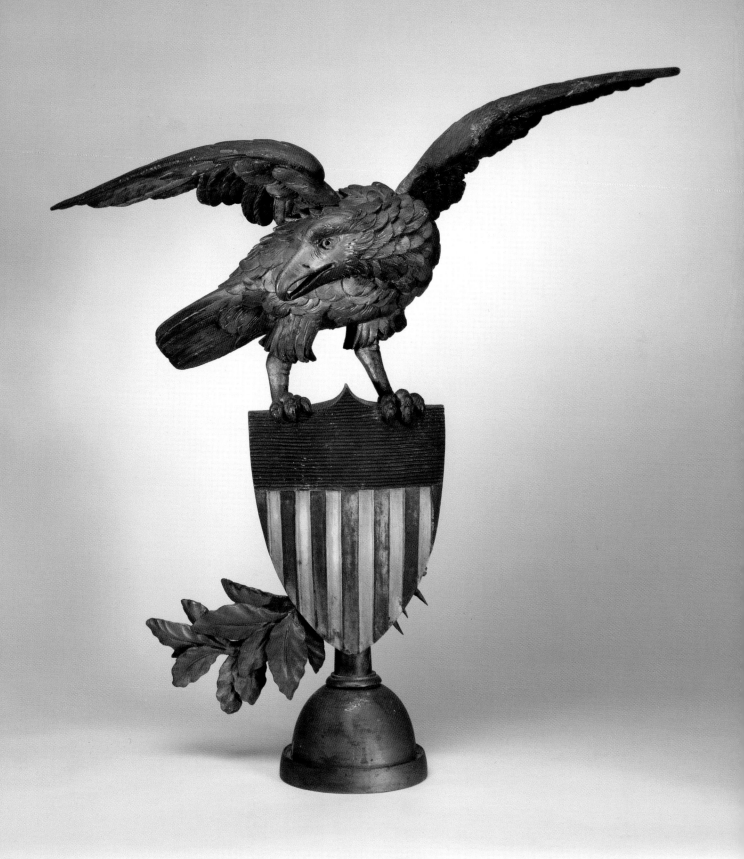

EAGLE WALL PLAQUE

1835–45
Carved white pine with original gilt and polychrome
17¾ x 16½ x 6¾"

Private collection

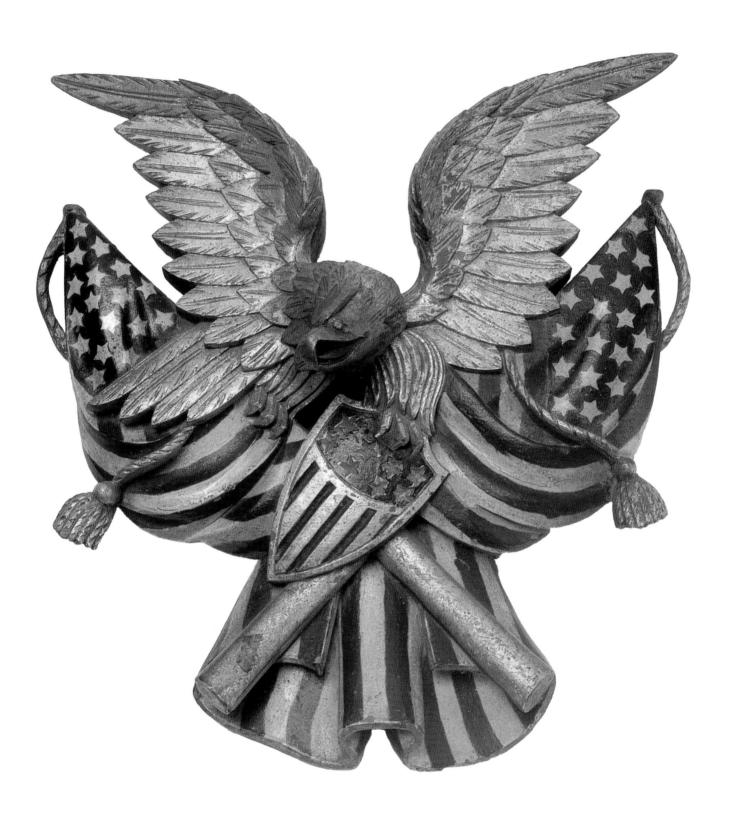

ARCHITECTURAL ORNAMENT: EAGLE IN FLIGHT

Artist unknown
Found in Cohasset, Massachusetts, c. 1810
Carved and gilded wood
approx: 48 x 108 x 8"

EAGLE WITH OUTSPREAD WINGS

Attributed to Wilhelm Schimmel (1817–1890)
Carlisle, Pennsylvania, 1870–1890
Carved, gessoed and painted pine
20 x 41 x 6½"

Collection, Museum of American Folk Art, New York
Gift of Mr. and Mrs. Francis S. Andrews 1982.6.10
Photograph by John Parnell

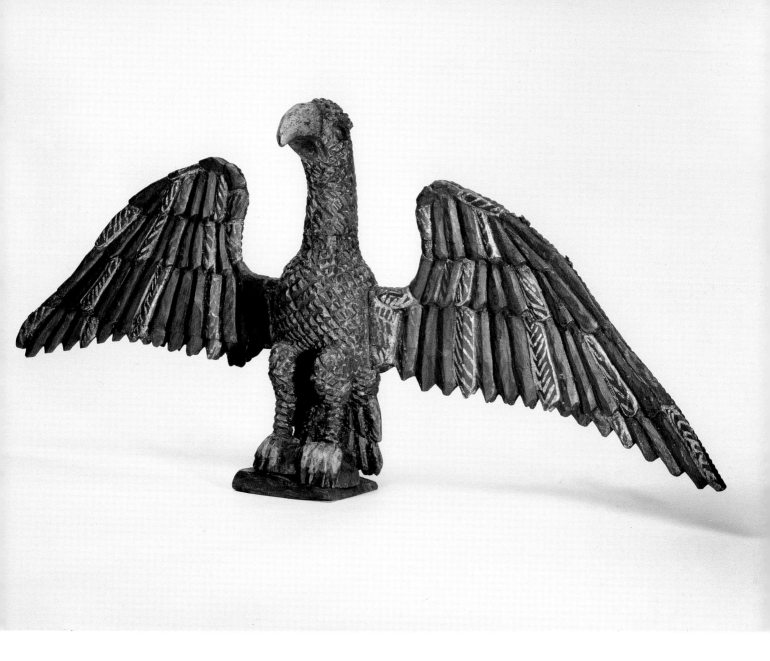

CARVED EAGLE SHIP'S FIGURE HEAD

Painted wood, iron
30³⁄₁₆ x 32¹⁄₂ x 14³⁄₄"

Collection, Michael Del Castello

JOCKEY FIGUREHEAD FROM THE BARK "RACER" PAGE 74

1860
White pine with original polychrome
54 x 14 x 15¹⁄₂"

Collection, Michael Del Castello
Photograph by Steve Jague
Courtesy of David A. Schorsch, Inc.

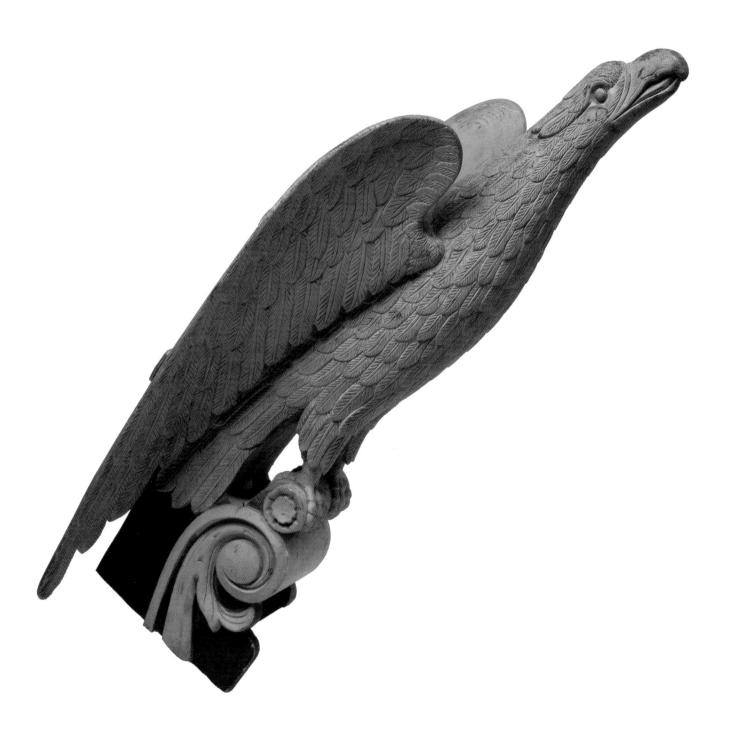

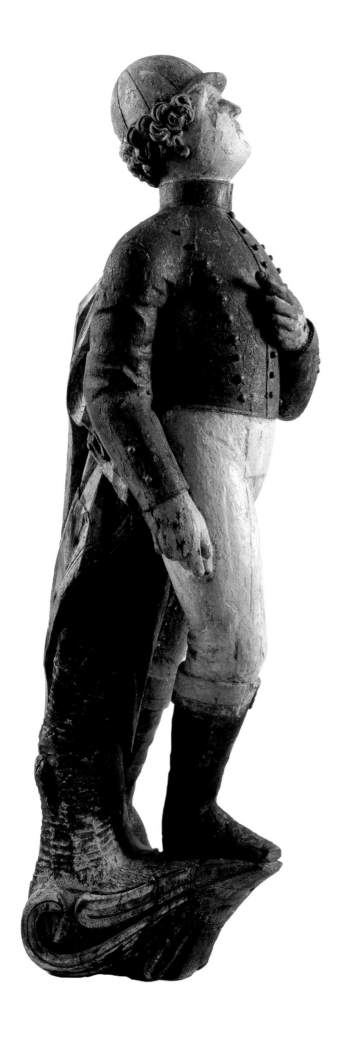

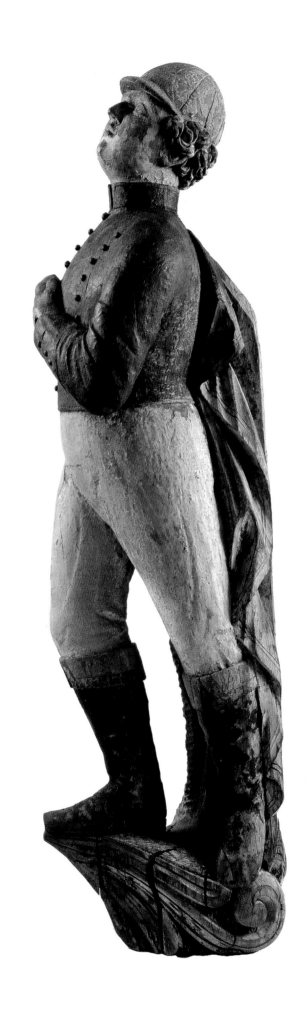

CROCHETED COVERLET

Artist unknown
19th century
Cotton
114 x 104″

Collection, Margaret and Bill Pearson

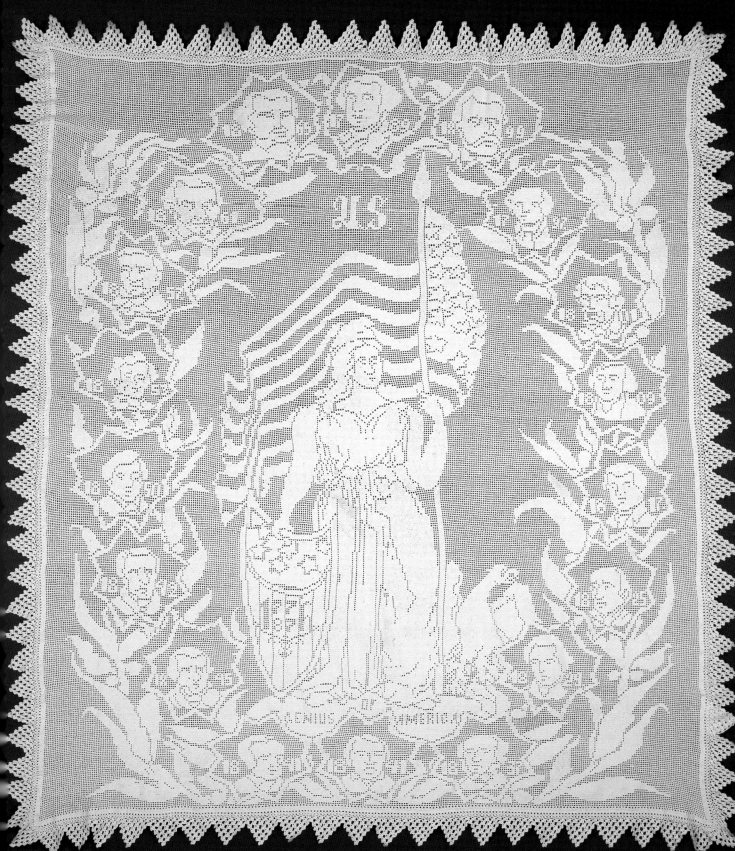

SILVER DOLLAR QUILT

Artist unknown
Ohio, 1830
Wool
80 x 77″

Collection, Margaret and Bill Pearson

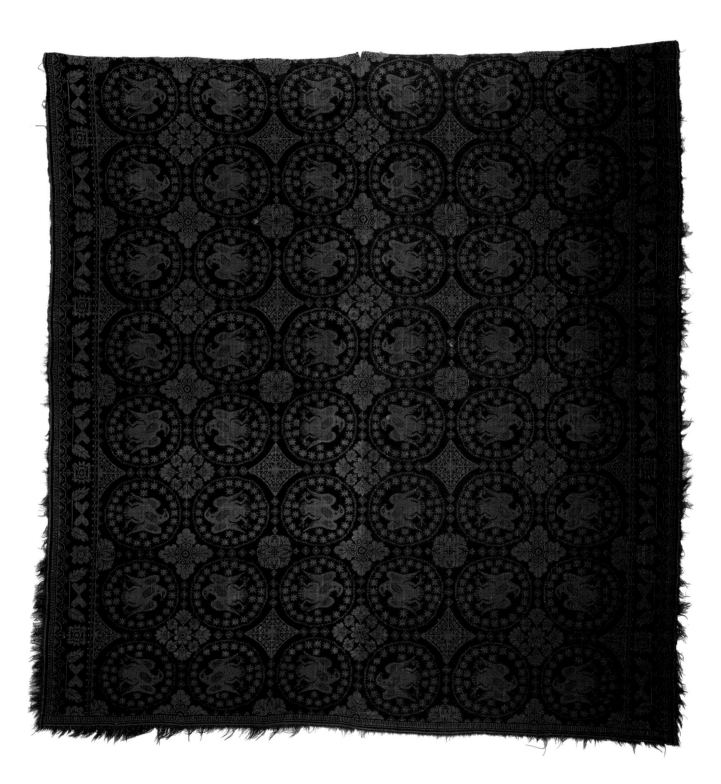

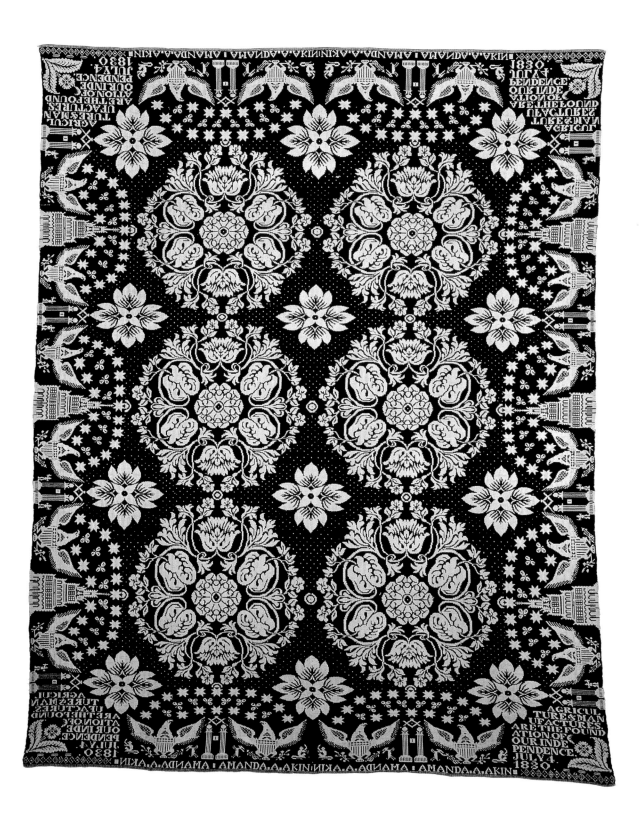

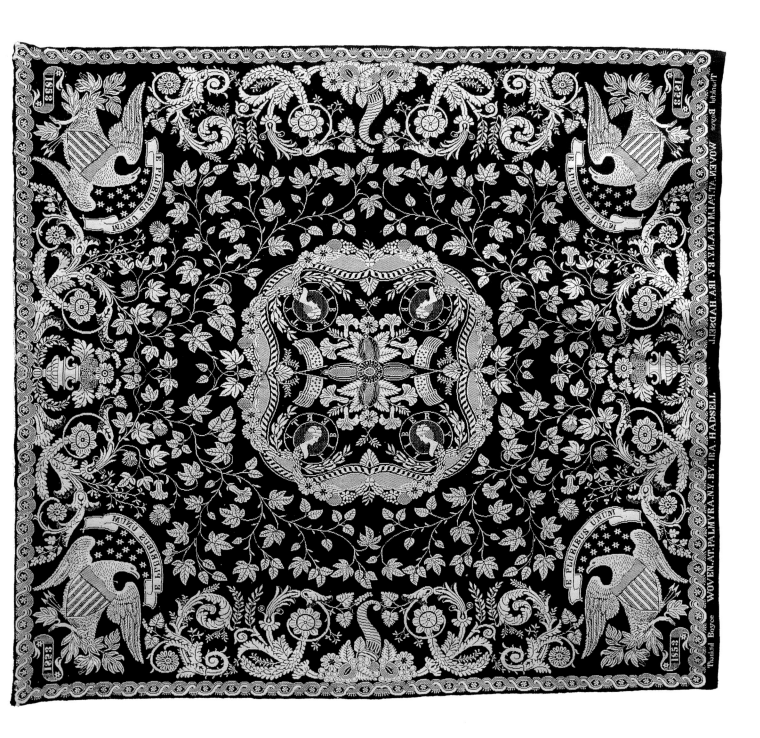

BLUE AND WHITE JACQUARD COVERLET
FOR AMANDA A. AKIN

PAGE 80

American School, New York, 1830
Blue wool and white cotton, double weave
87 x 76"

Collection, Hirschl & Adler Galleries, Inc.

LIBERTY DESIGN COVERLET FOR THANKFUL BOYCE

PAGE 81

Ira Hadsell (1813–after 1875)
Palmyra, New York, 1853
Wool and cotton
88 x 80"

Collection, Museum of American Folk Art, New York
Donated in loving memory of Ruth Shmigelsky McGiver and
John I. McGiver, temporary guardians of this fine coverlet 1992.16.1
Photograph by Gavin Ashworth

ALL AMERICAN STAR QUILT

OPPOSITE

Quiltmaker unidentified
New York State, 1940–1945
Pieced cotton
87 x 72"

Collection, Museum of American Folk Art, New York
Gift of Cyril I. Nelson 1987.17.2

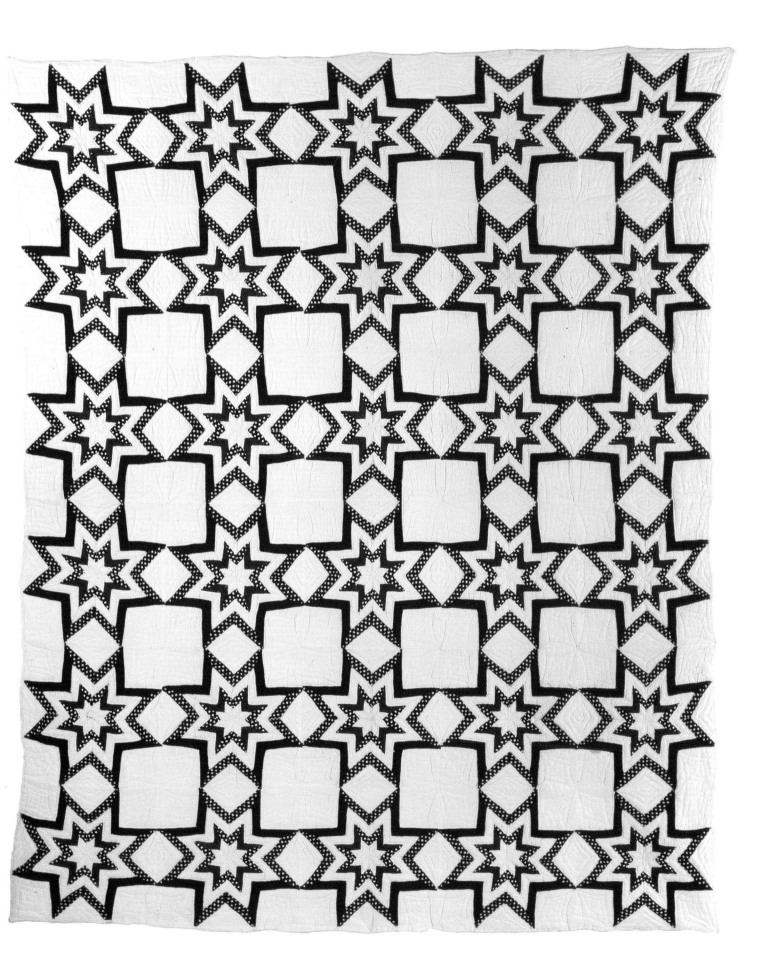

FAMOUS AMERICANS QUILT

L.B. Evans
1951–2
Pieced, appliqued and embroidered cotton, rayon, silk and wool
90 x 61″

Collection, America Hurrah Antiques, New York City
Photograph courtesy of America Hurrah Archive

This quilt depicts the important political, military and social figures of the 1940s and 1950s. Each personality is identified in embroidery with relevant annotations and quotations. Over 80 famous Americans are portrayed, and the list includes: Harry S. Truman, Franklin Delano Roosevelt, Eleanor Roosevelt and Fala, Bess and Margaret Truman, Alben Barkley, V.P., Dwight D. Eisenhower, Herbert Hoover, Sen. Robert Taft, Dean Acheson, Thomas Dewey, John Foster Dulles, J. Edgar Hoover, Harold Stassen, Henry Ford II, Earl Warren, Alger Hiss, Whittaker Chambers, Walter Reuther, Estes Kefauver, Henry Wallace, John L. Lewis, Gen. Douglas MacArthur, Gen. Omar Bradley, Gen. Carl Speatz, Gen. George Marshall, Gen. Matt Ridgway.

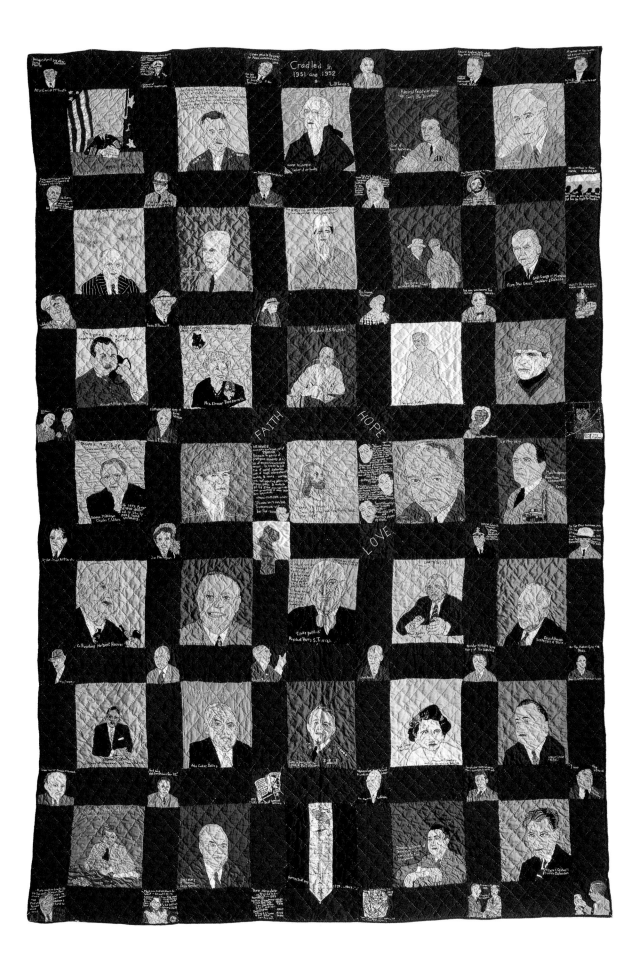

QUILT MADE OF CIGAR BANDS

Artist unknown
19th century
Silk
85 x 69½"

Collection, Margaret and Bill Pearson

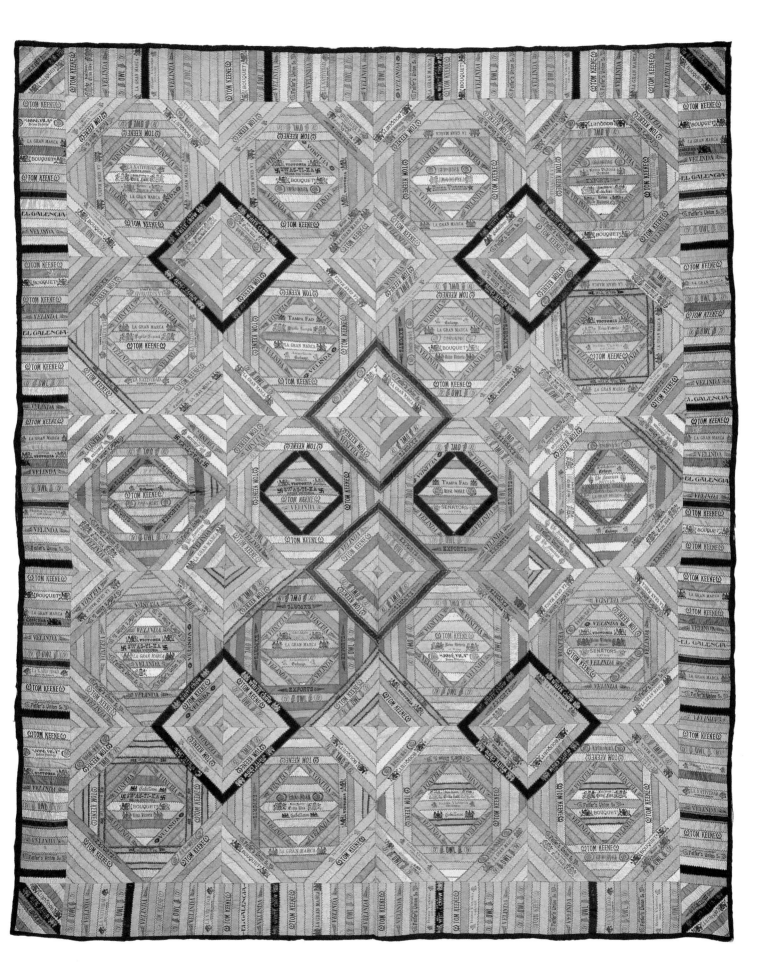

SHAKER ARMED ROCKER

Mt. Lebanon, New York c. 1880–1920
Maple, wool chair tape
$42\frac{5}{8}$ x $23\frac{7}{8}$ x $29\frac{3}{8}$"

Private collection
Photograph courtesy of David A. Schorsch, Inc.

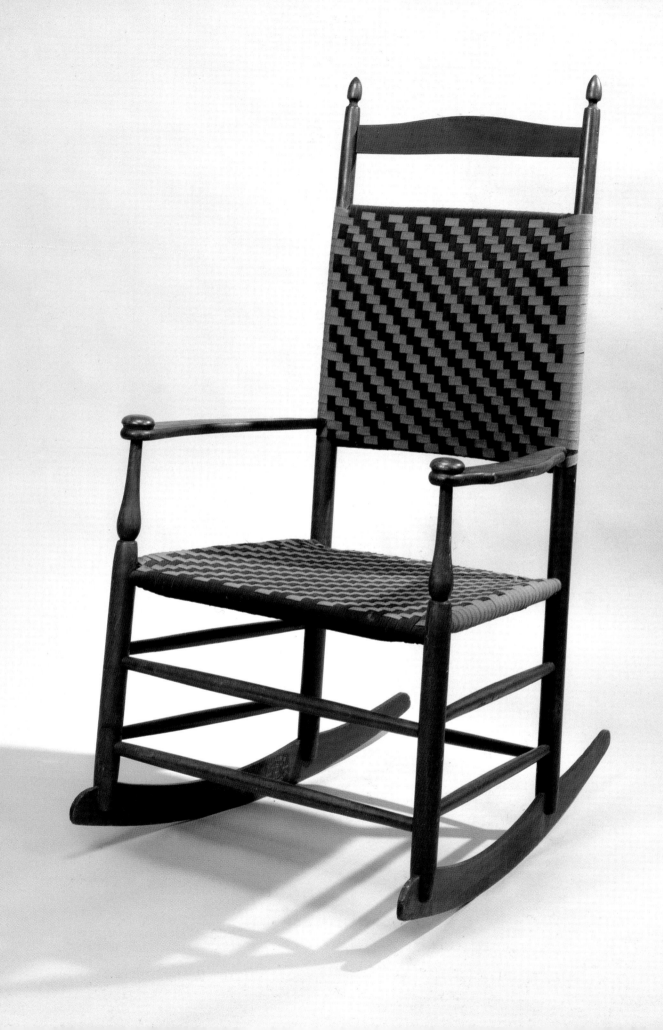

MATCH STICK VIOLIN

Folsom Prison, California, 20th century
22 x 8½″

Collection, Margaret and Bill Pearson

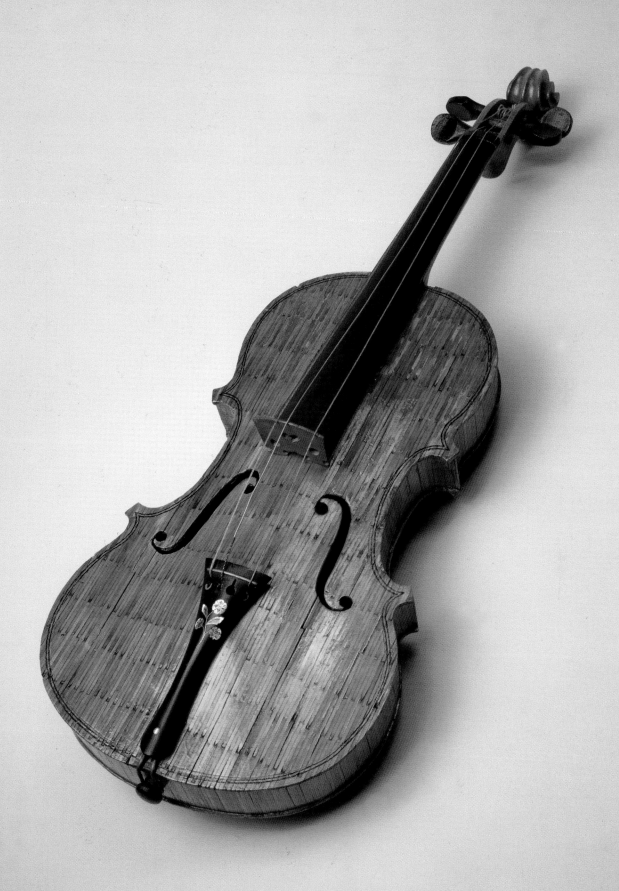

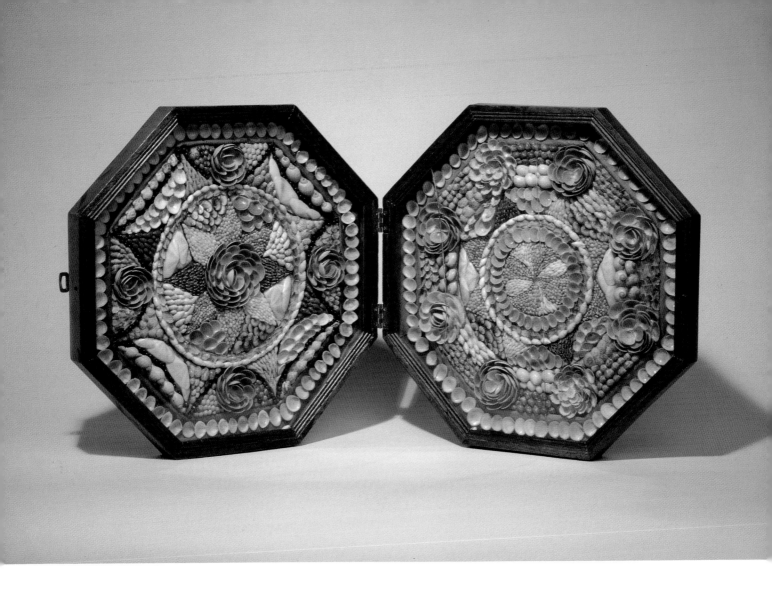

SAILOR'S VALENTINE

Artist unknown
1880
Shells and paper
27½ x 13¾"

Collection, Margaret and Bill Pearson

SAILOR OR SOLDIER'S HANGING CUPBOARD

Oliver Stedman
North Kingston, Rhode Island, 1861
Maple and pine with wood, ivory and bead inlays
29 x 32 x 9"

Collection, Michael Del Castello
Photograph courtesy of Walters Benisek Art & Antiques

Handed down in the Stedman family and stored in their attic until 1993

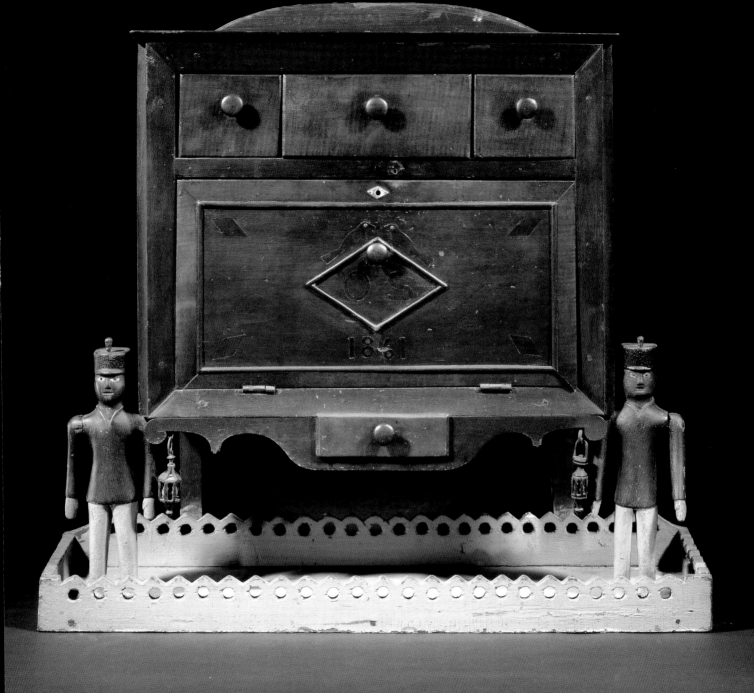

SELF PORTRAIT / LOVE TOKEN

Artist unknown
C. 1825
Watercolor and ink on paper
6 x 8"

Collection, Michael Del Castello

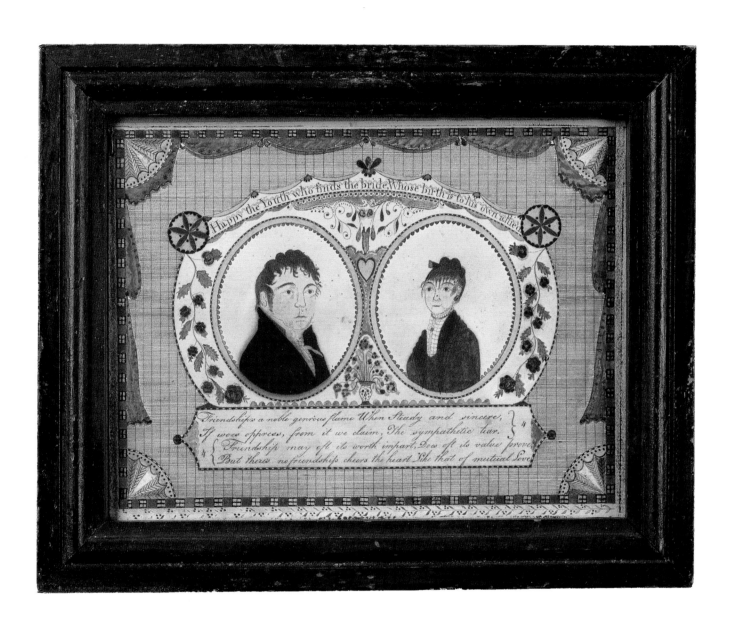

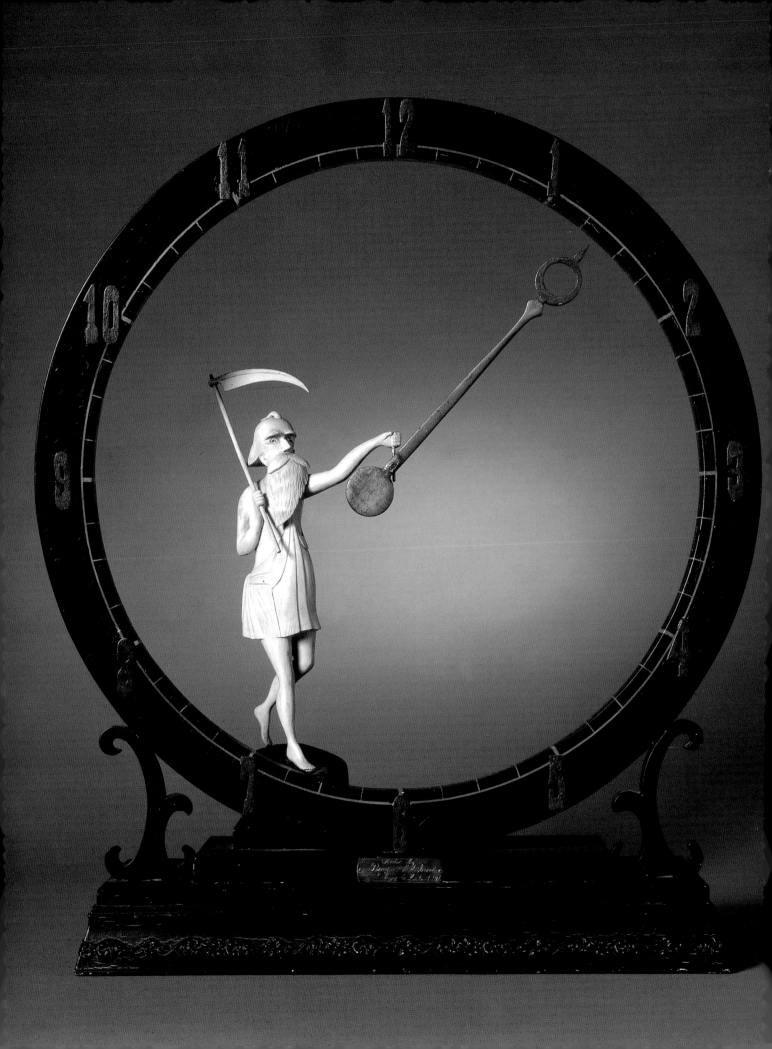

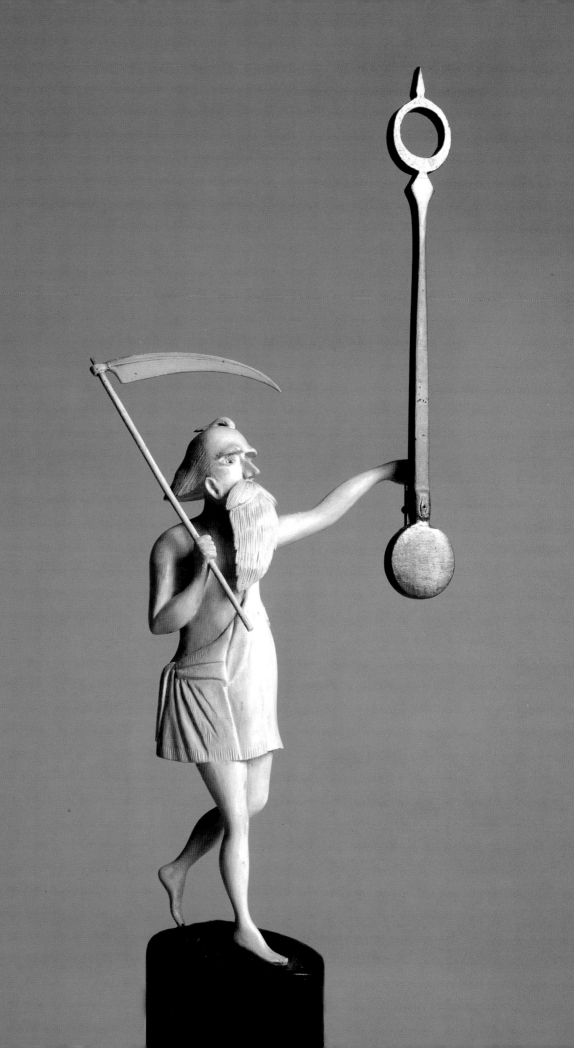

MYSTERY CLOCK PAGE 96

Percy M. Clure & Erik Albertson, 1865–1906
27 x 23½″

Collection, Michael Del Castello
Photograph by Steve Jague
Courtesy of David A. Schorsch, Inc.

BLANKET CHEST OPPOSITE

Probably Vermont, c. 1820
Poplar wood with original painted decoration
24¾ x 40½ x 15½″

Private collection
Photograph courtesy of David A. Schorsch, Inc.

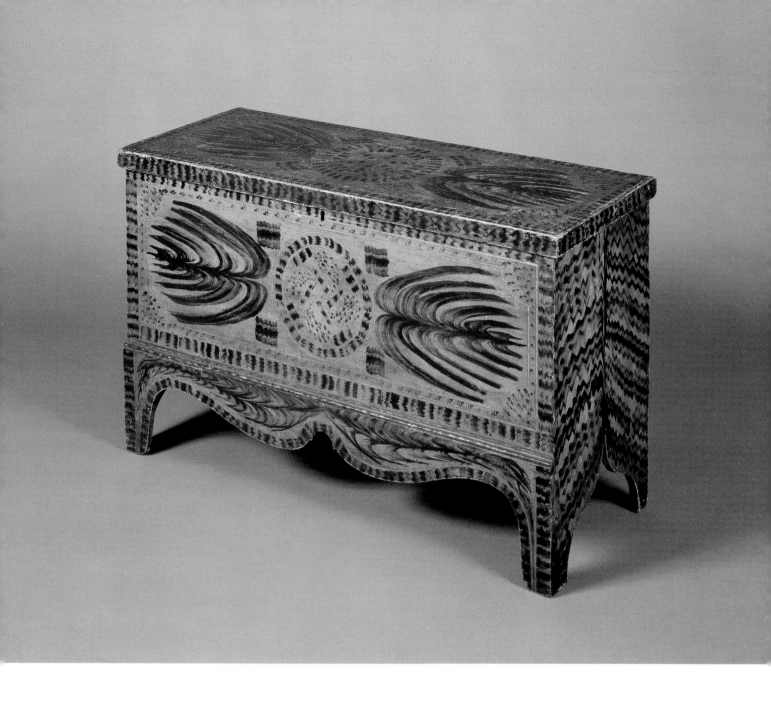

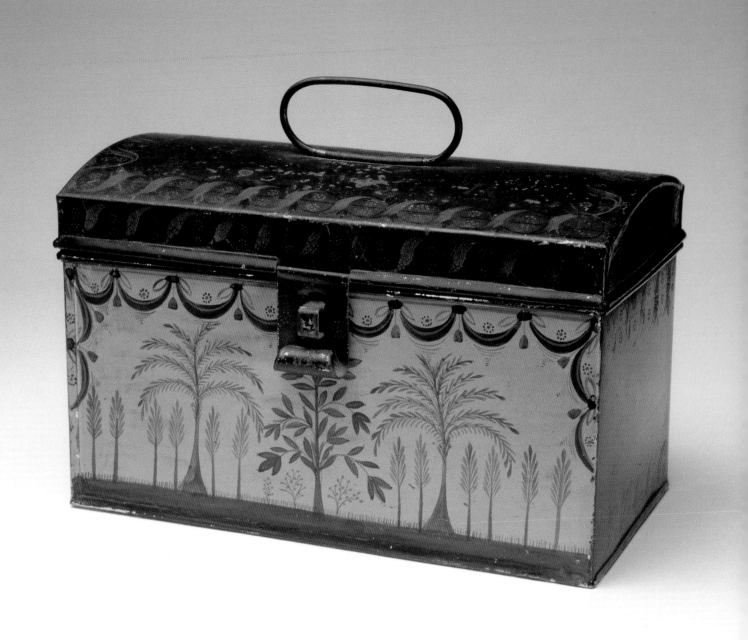

PAINTED TIN DEED BOX

Decorated in the manner of Rufus Porter or a contemporary
New England, c. 1835
9⁷⁄₈″

Private collection

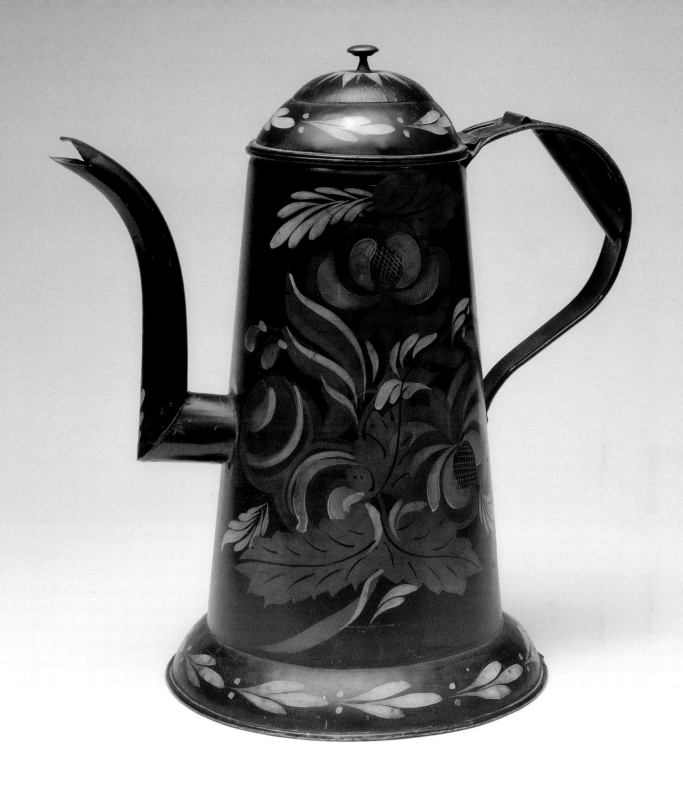

PAINT-DECORATED TINWARE COFFEE POT

Decoration attributed to Ann Butler
East Greenville or Brandy Hill, New York, c. 1840
$10^{13}/_{16}$ x $8^{7}/_{8}$ x $6^{3}/_{4}''$

Private collection

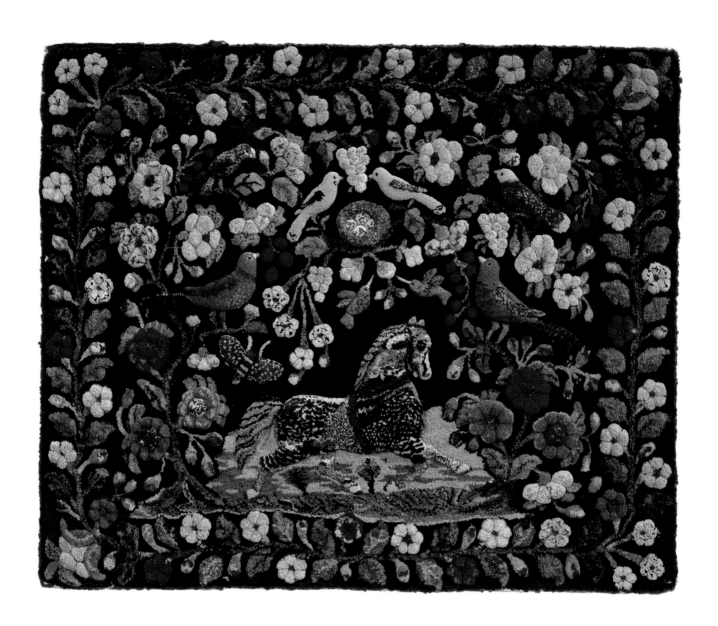

WALDOBORO TYPE HOOKED RUG

Maine, c. 1860
Wool
26¼ x 36¾"

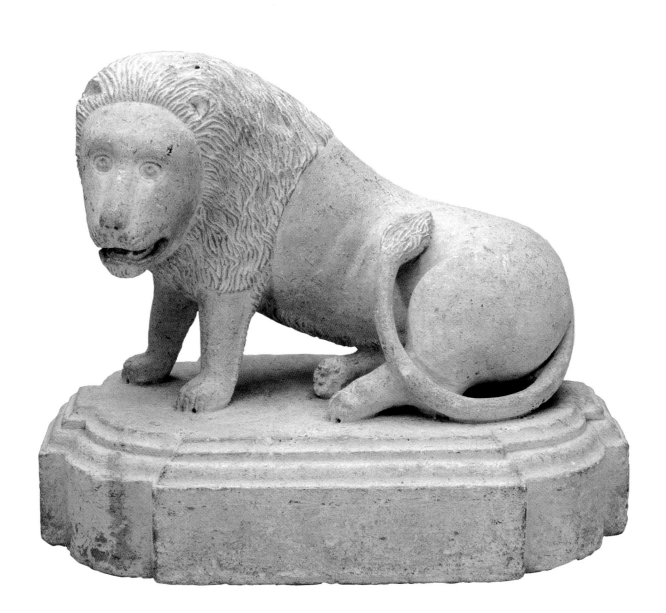

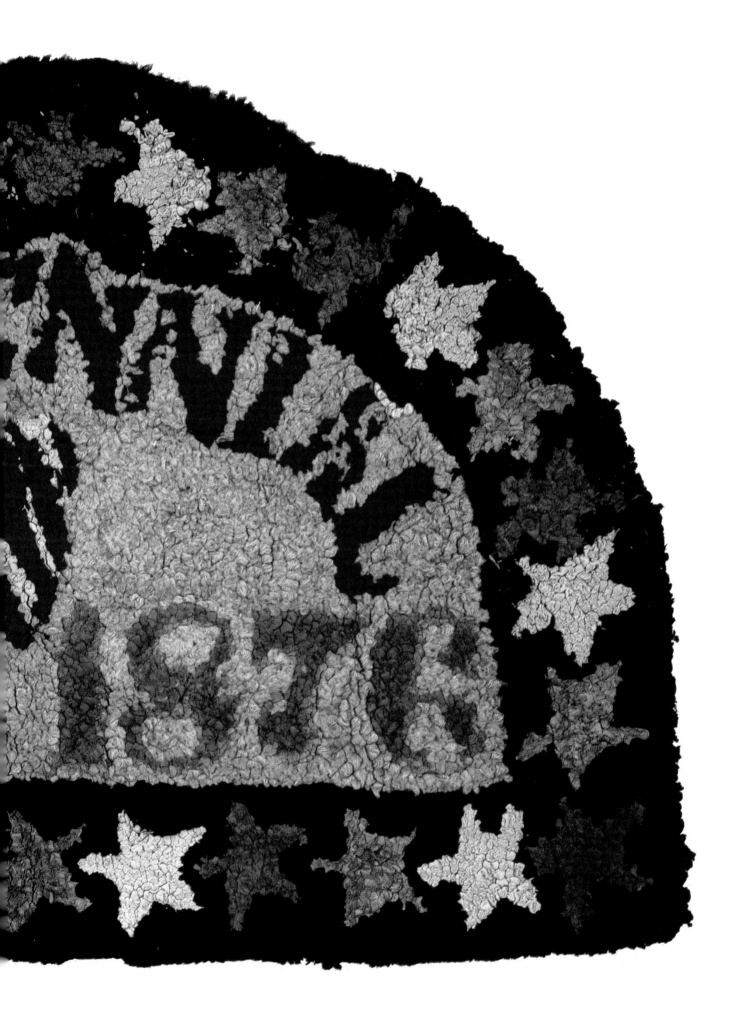

SEATED LION PAGE 103

Artist unknown
Probably Pennsylvania or Ohio, 19th century
Carved white marble, unpolished
$8\frac{7}{8}$ x $11\frac{3}{16}$ x $6\frac{15}{16}$"

Collection, Michael Del Castello

HOOKED RUG: "CENTENNIAL" PAGE 104

Artist unknown
C. 1876
Wool on burlap
28 x 38"

Collection, Museum of American Folk Art, New York
Gift of Mr. George S. Stephenson 1976.5.1
Photograph by Gavin Ashworth

WALL CASE OPPOSITE

Artist unknown
New Mexico, 1880
Painted wood
19 x 28"

Collection, Cody Pearson

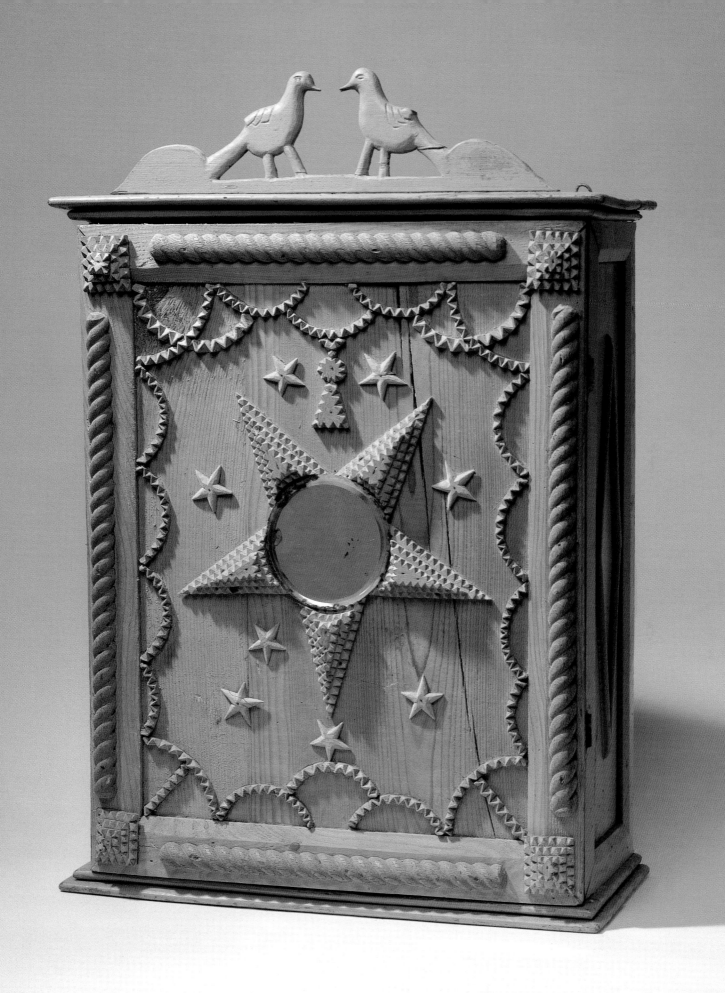

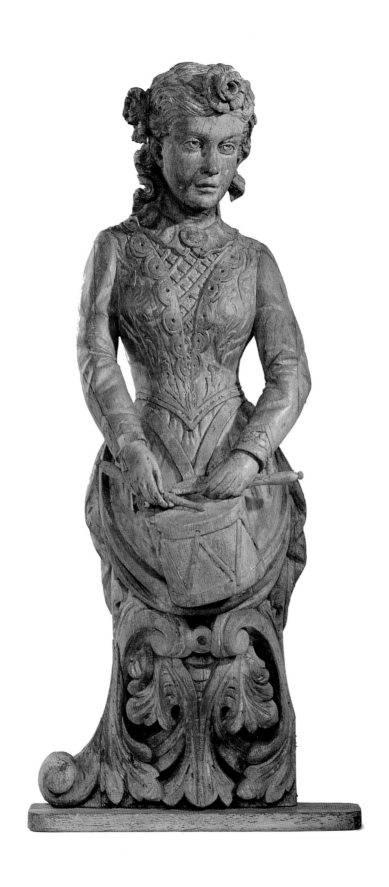

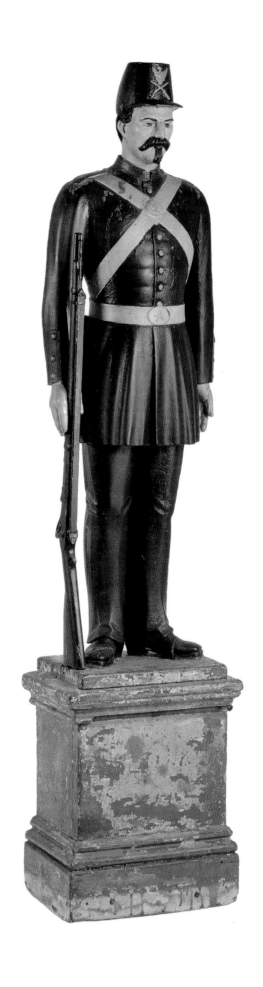

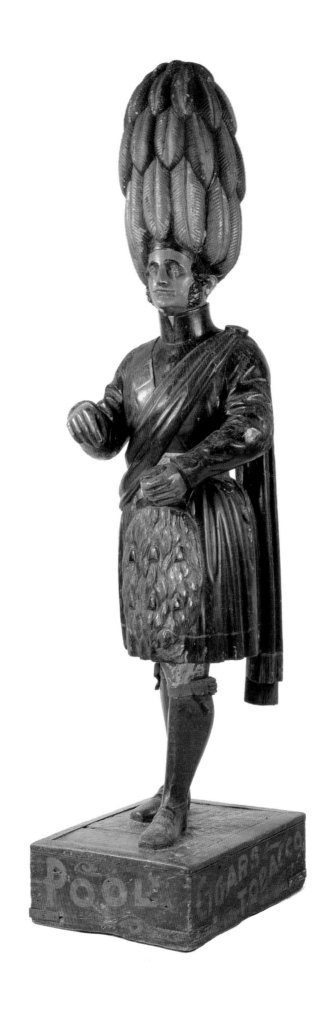

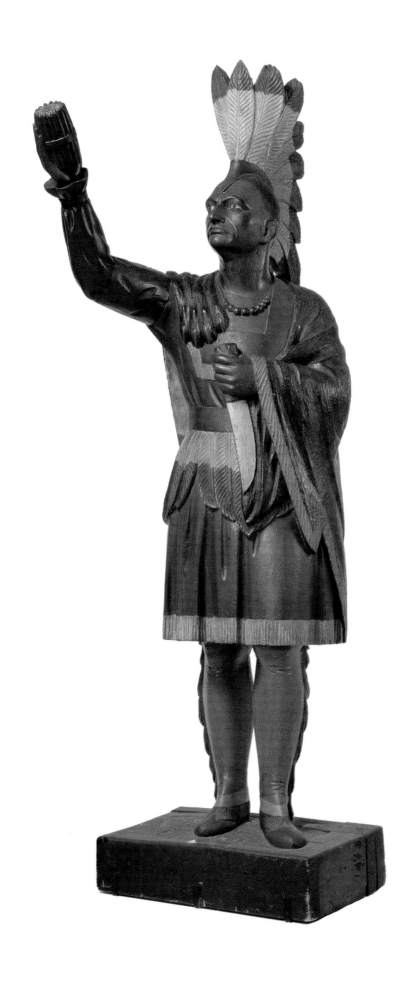

CIRCUS WAGON FIGURE: LADY DRUMMER PAGE 108

Artist unknown
C. 1880
Painted wood
39⅝ x 18⅛ x 8"

TRADE FIGURE OF A MILITIA SOLDIER PAGE 109

Artist unknown
C. 1865
Carved, polychromed wood
69⅝ x 16 x 11¼"

SCOTTISH HIGHLANDER CIGAR STORE FIGURE PAGE 110

Samuel Robb (1851–1928)
New York, c. 1880
Polychromed wood
92 x 23 x 27¼"

CIGAR STORE INDIAN PAGE 111

John L. Cromwell (1805–1873)
New York, New York, 1860
Polychromed wood
74¾ x 23 x 31"

PUNCH TRADE FIGURE OPPOSITE

Attributed to the Robb workshop
New York, c. 1880
Polychromed wood, iron wheels
71 x 23 x 23"

Collection, Michael Del Castello (All above)
Used in front of tobacconists shops.

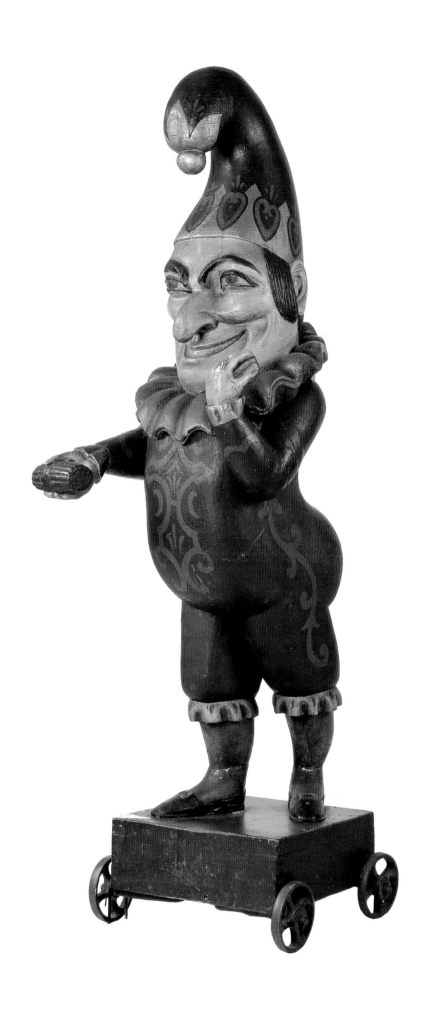

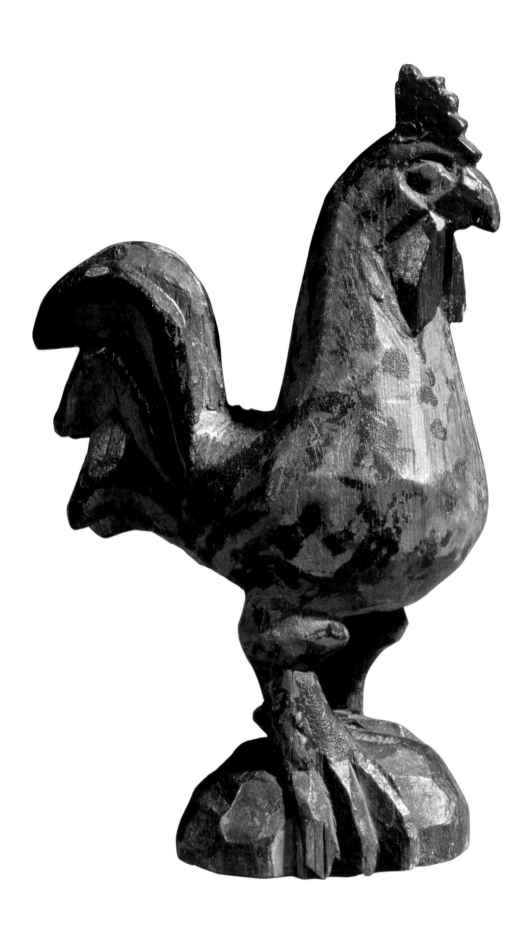

SAILOR'S WHIMSY PAGE 114

Artist unknown
Polychromed wood
30¼ x 11½ x 11½"

Collection, Michael Del Castello

ROOSTER PAGE 115

Wilhelm Schimmel (1817–1890)
Carlisle, Pennsylvania, 1870–1890
Polychromed wood
8 x 5⅛ x 2⅝"

Collection, Museum of American Folk Art, New York
Gift of Ralph Esmerian 1990.26.1
Photograph by Helga Studios

MUSICIAN WITH LUTE OPPOSITE

Clark Coe (1847–1919)
Killingworth, Connecticut, early 20th century
Figure: wood; Lute: metal and wood
30" high

Collection, Museum of American Folk Art, New York
Gift of the Museum of Modern Art from the
collection of Gordon and Nina Bunshaft 1995.1.1
Photograph by Gavin Ashworth

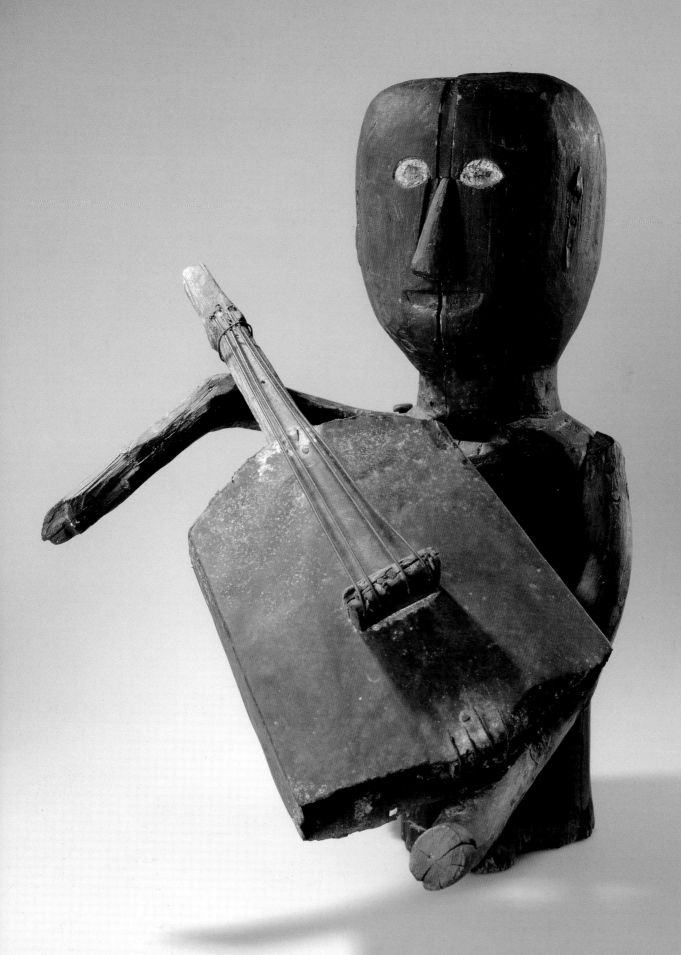

ABRAHAM LINCOLN

Elijah Pierce (1892–1984)
Columbus, Ohio, c. 1975
Carved and painted wood relief
14½ x 9¼"; 22 x 16½ x 3½" framed

Collection, Museum of American Folk Art, New York
Gift of Robert Bishop 1993.4.39

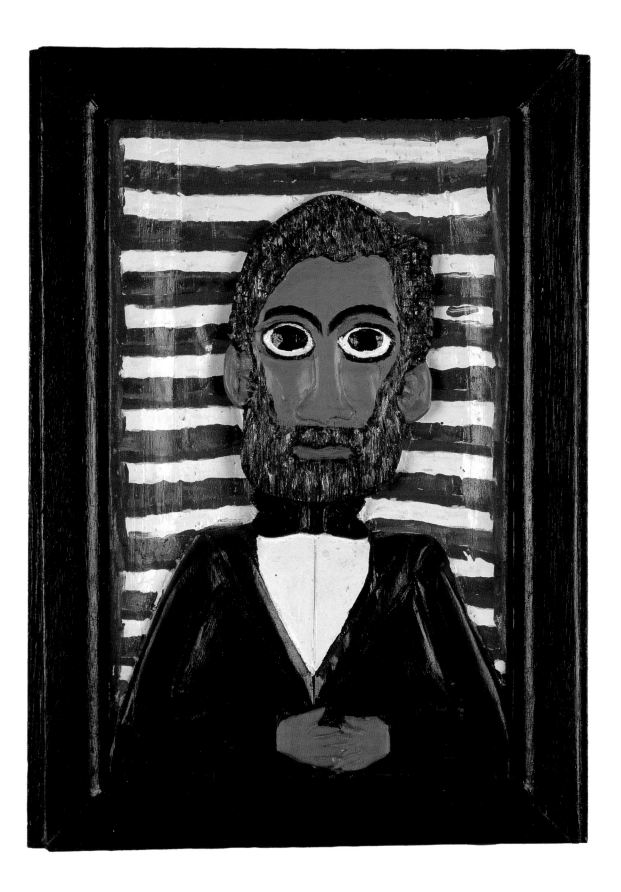

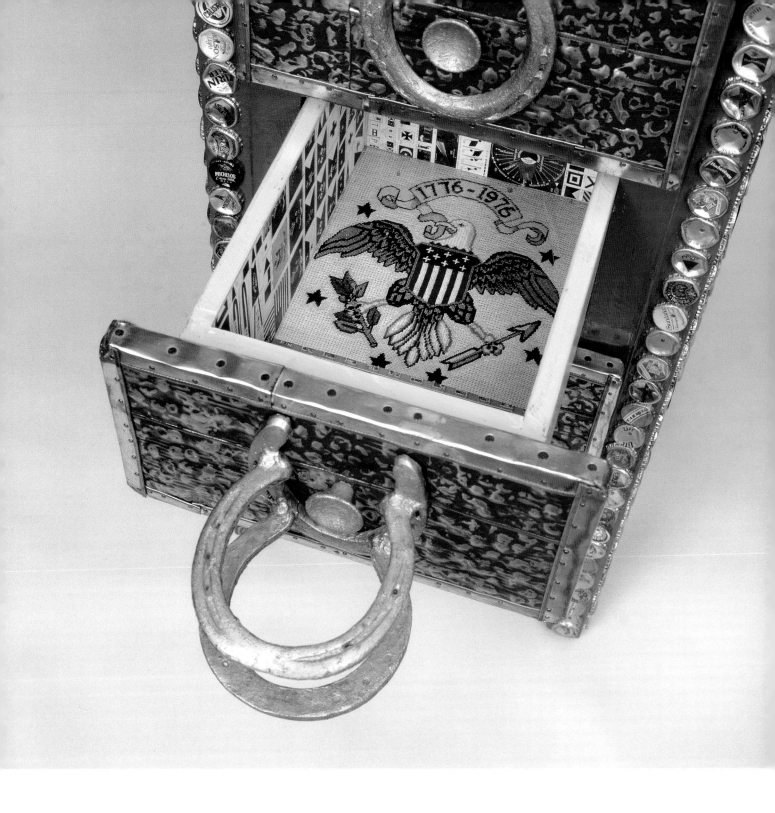

HORSE SHOE CHEST

John Bok, b. 1959

C. 1992

Painted wood and mixed media

35 x 24 x 24"

Promised gift of Charmaine and Maurice Kaplan

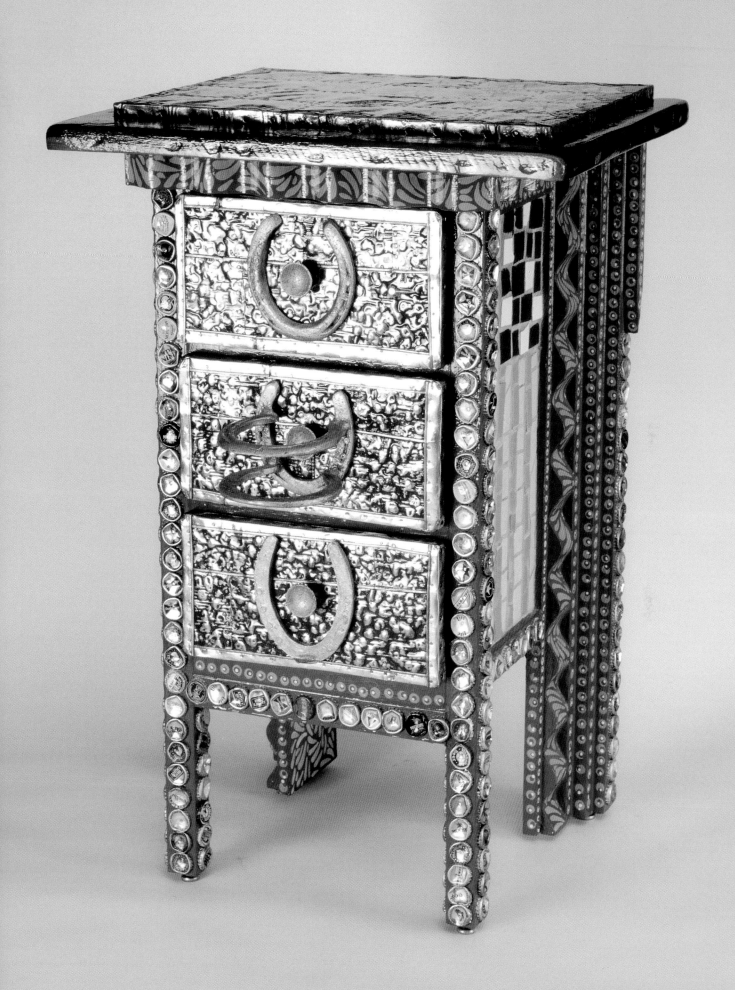

SPACIOUS SKIES QUILT

Charlotte Warr-Anderson
Kearns, Utah, 1985–1986
Appliquéd and reverse appliquéd cotton, polyester blends
72 x 71½"

Collection, Museum of American Folk Art, New York
The Scotchguard ® Collection of Contemporary Quilts 1986.14.2

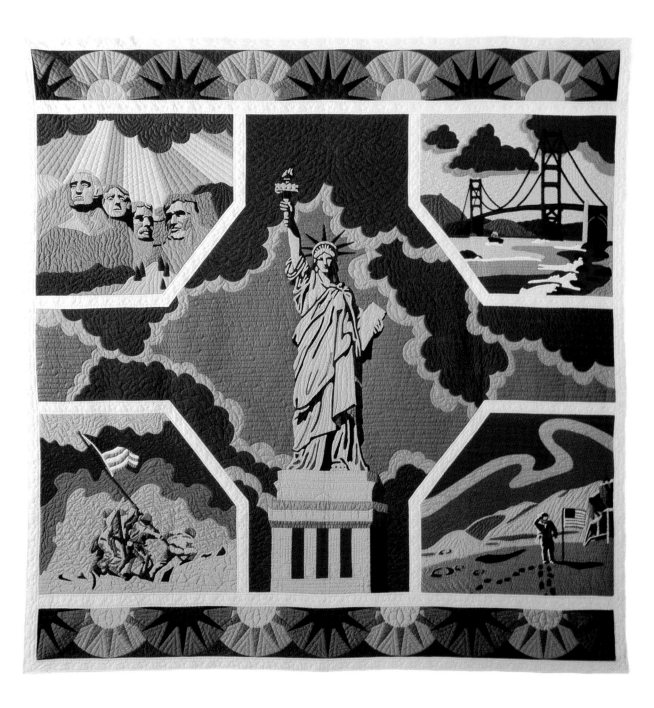

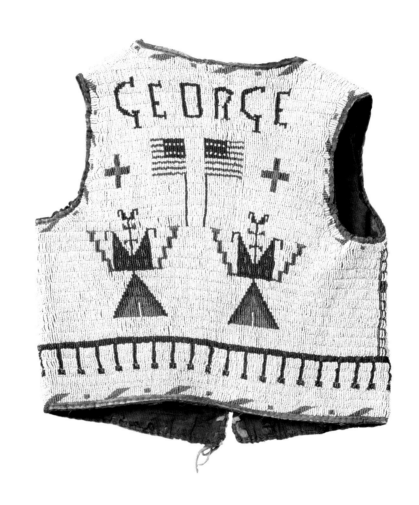

BOY'S VEST

Lakota, late 19th – early 20th century
Native tanned hide, glass beads, cotton lining
14 x 14″

Collection, America Hurrah Antiques, New York City
Photograph courtesy of America Hurrah Archive

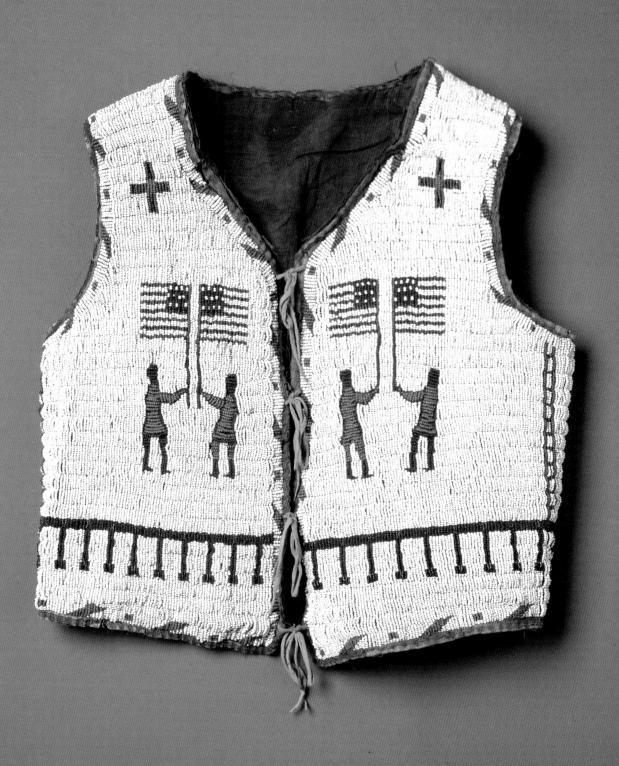

NAVAJO RUG

Arizona, c. 1920's
Handspun wool
76 x 54½"

Collection, Mingei International Museum
Gift of Susan L. Eyer

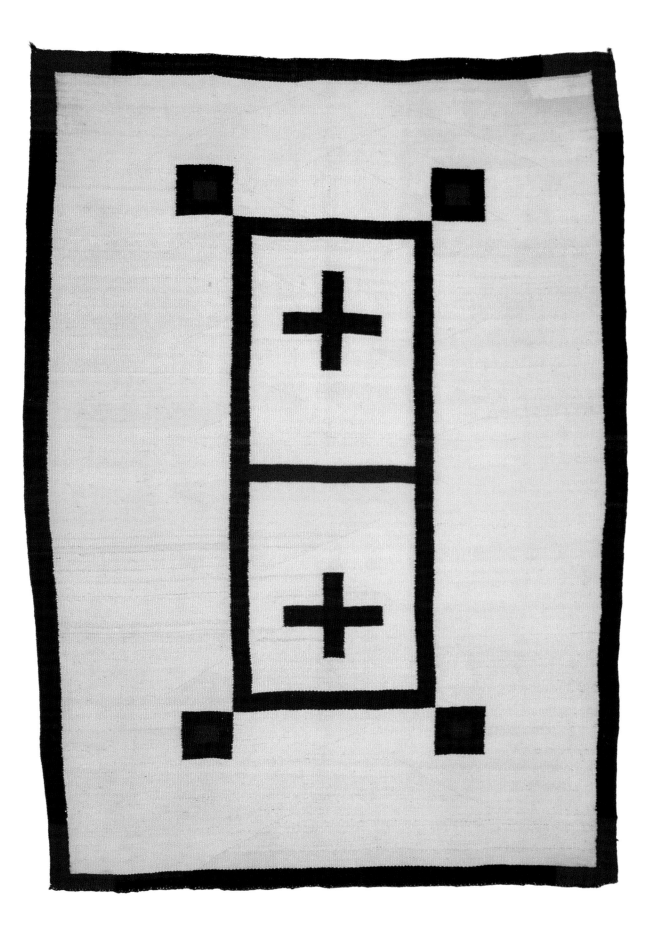

STANDER CAROUSEL HORSE

Gustav A. Dentzel

C. 1890

Carved and painted wood

Restored by William H. Dentzel, III
Collection, Marion W. and William H. Dentzel, II and Family
Photograph by Henry Fechtman

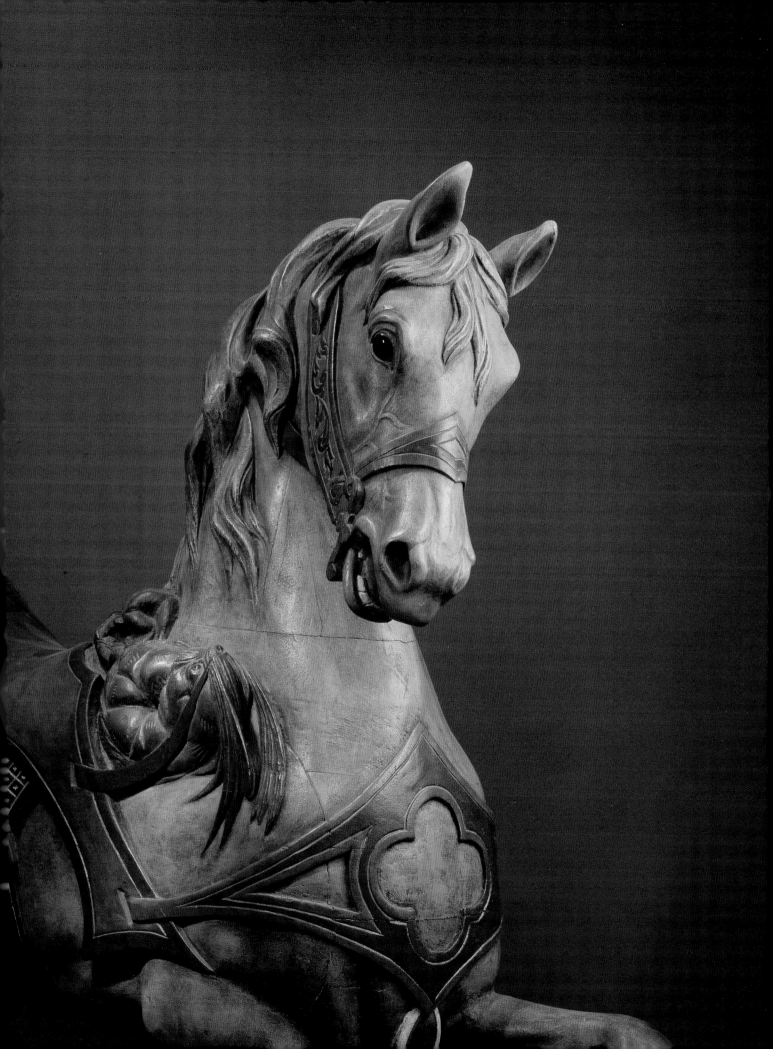

CAROUSEL RABBIT

William H. Dentzel
C. 1915
Carved and painted wood

Restored by Nina Fraley
Collection, Marion W. and William H. Dentzel, II and Family
Photograph by Henry Fechtman

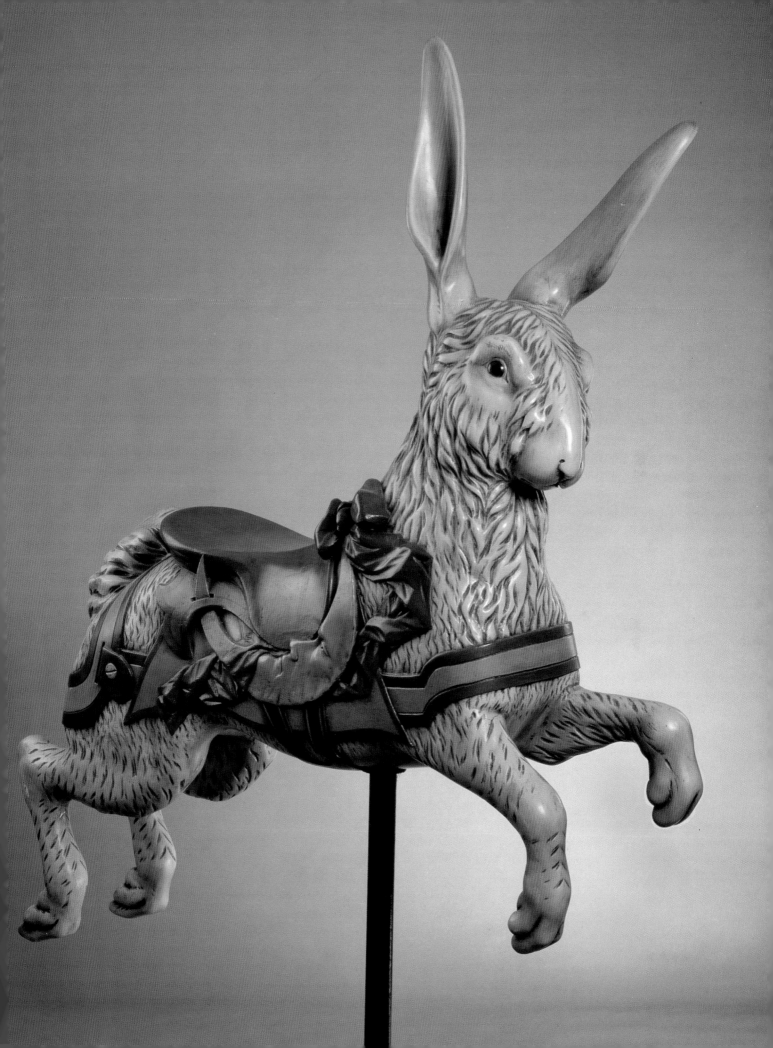

CALABASH OPPOSITE

Hawaii, 19th century
Koa wood
12 x 17½"

Collection, Mingei International Museum
Gift of Mr. and Mrs. George Lazarnick

LOUNGE AND FREE FORM ARM PAGE 134
RIGHT ROCKING CHAIR

George Nakashima
Designed, 1962 Production, 1967
Black walnut, hickory
35 x 30 x 29"

Promised gift of Charmaine and Maurice Kaplan

NEW CHAIR PAGE 135

George Nakashima
Designed, 1955 Production, 1993
Walnut, hickory
36¼ x 18¾ x 21"

Collection, Mingei International Museum
Gift of the George Nakashima Family

BOWL PAGE 136

Bob Stocksdale, b. 1913
Early 1970's
Purple leaf plum wood
3³⁄₁₆ x 6⅞ x 5¹³⁄₁₆"

Collection, Mingei International Museum
Gift of Forrest Merrill

MUSIC STAND PAGE 137

Wharton Esherick (1887–1970)
1962
Cherry
44 x 19½ x 20"

Promised gift of Charmaine and Maurice Kaplan

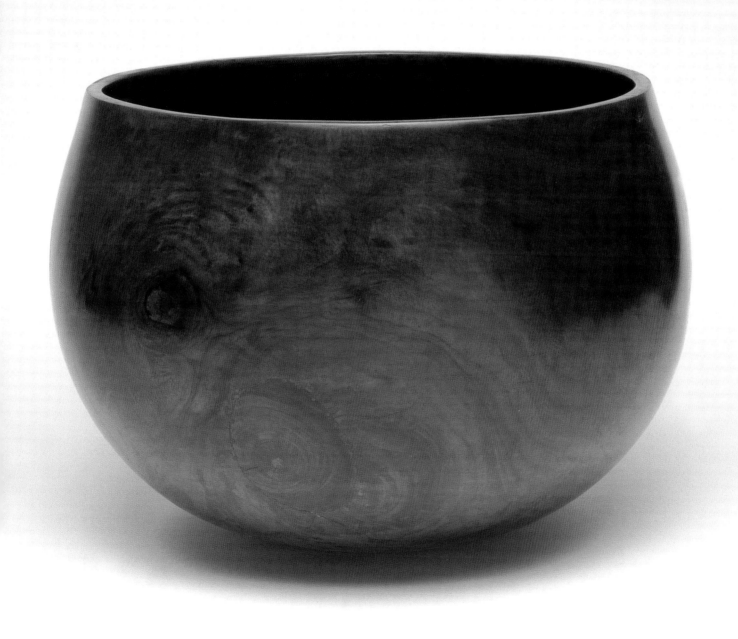

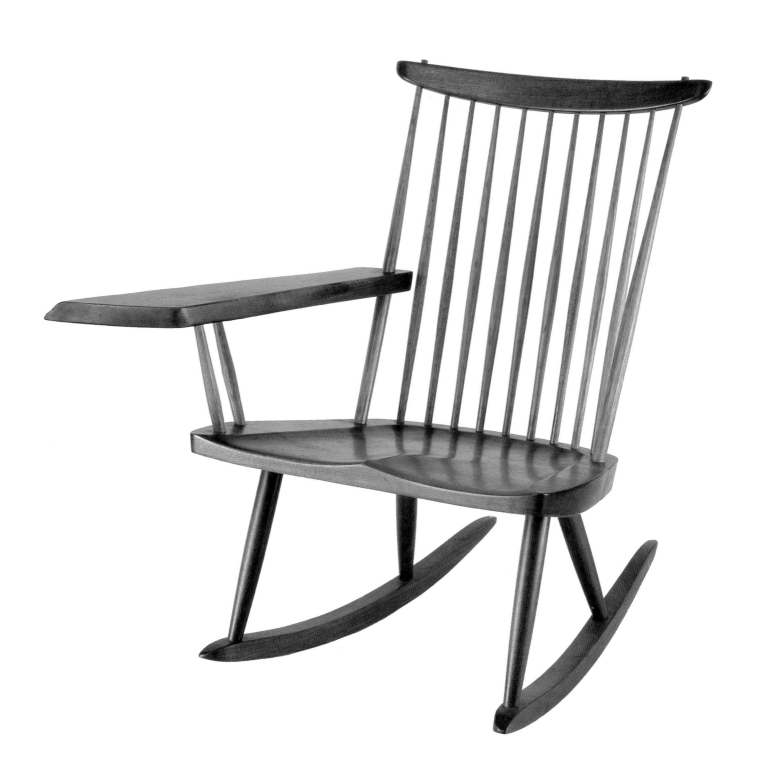

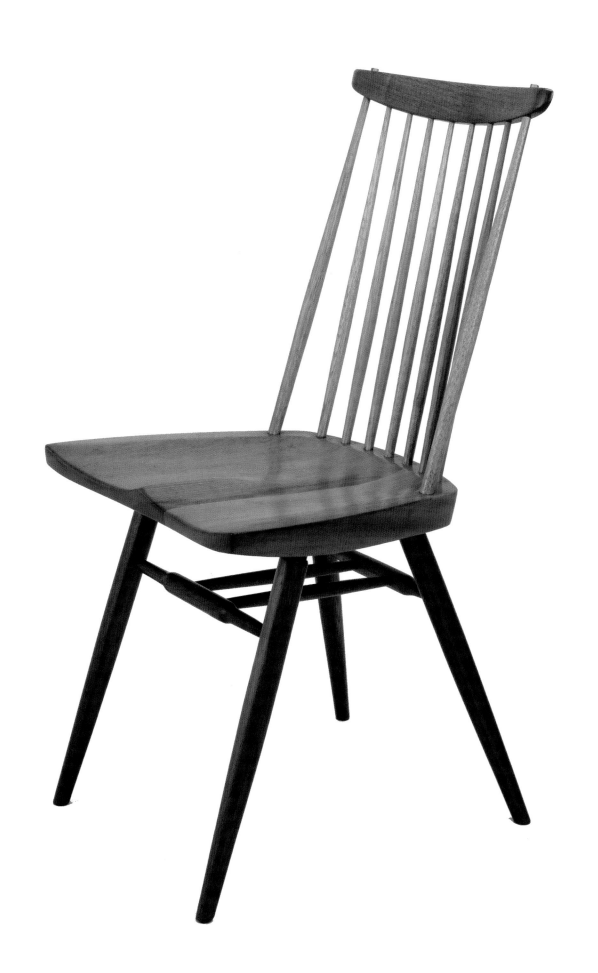

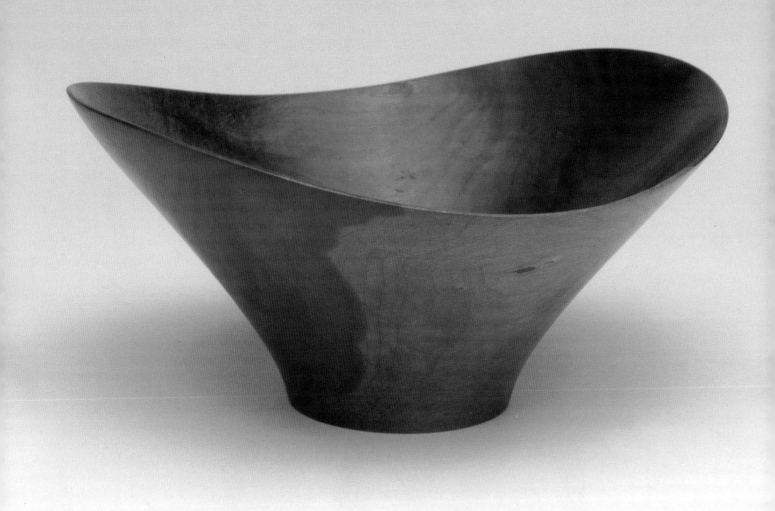

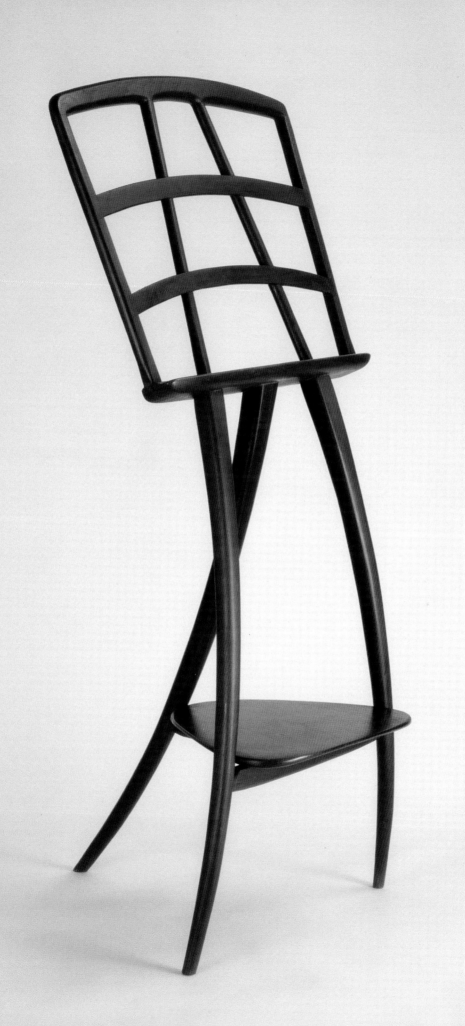

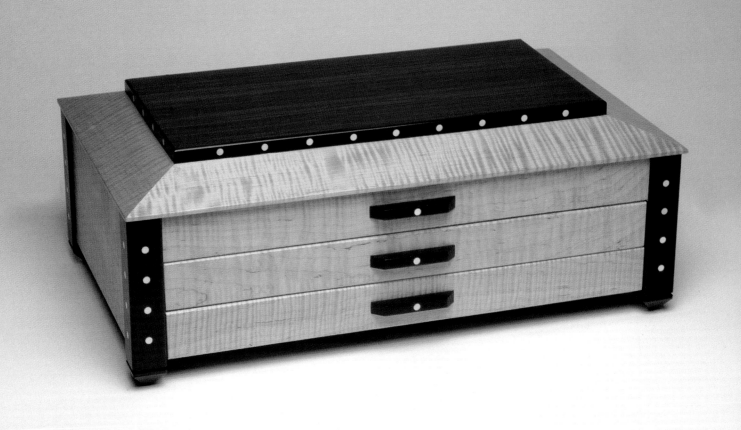

JEWELRY BOX

Brett Allen Hesser, b. 1966
Curly maple, ebony, ivory inlay (reclaimed from piano keys), 1995
7³/₄ x 21 x 12¹¹/₁₆"

Collection, Mingei International Museum

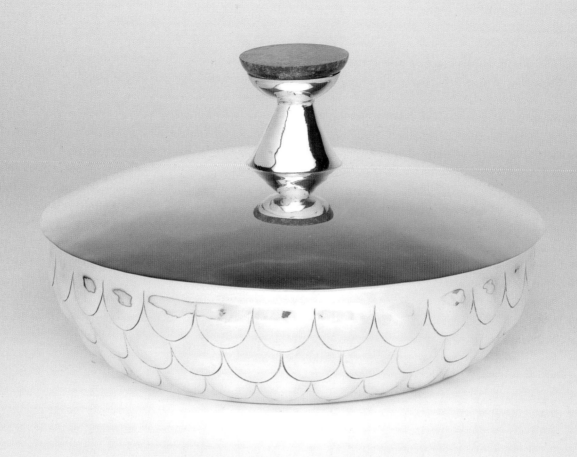

COVERED BOX WITH LAPIS KNOB

Henry Petzal, b. 1907
1980
Sterling silver
$4\frac{1}{2}$ x $7\frac{11}{16}''$

Collection, Mingei International Museum
Anonymous gift

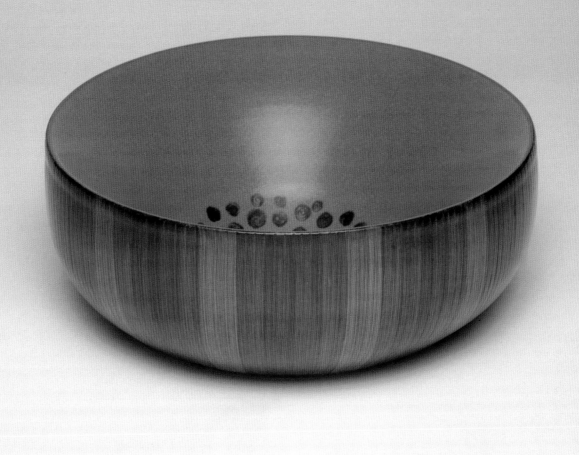

WATERMELON BOWL

Rupert J. Deese, b. 1924
1993
Glazed stoneware
$4\frac{1}{2}$ x $12\frac{5}{8}$″

Collection, Mingei International Museum

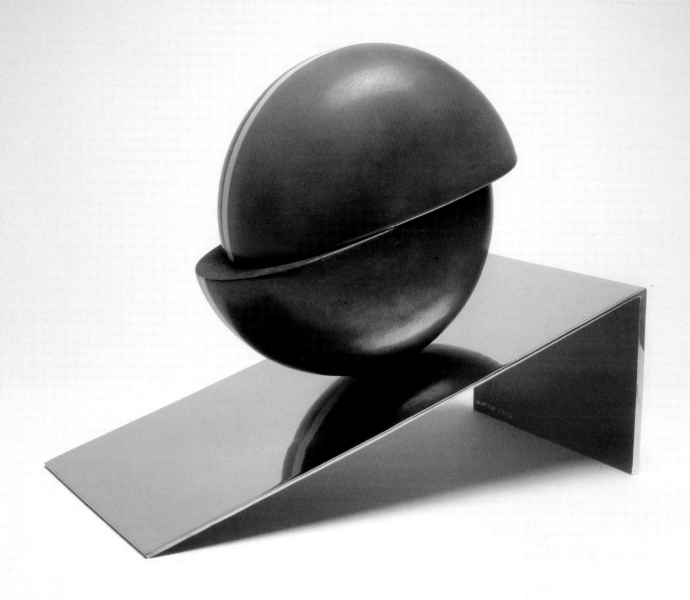

RACER

Harrison McIntosh, b. 1914
Stoneware on chromed steel, 1984
16 x 13 x 9"

Collection, Mingei International Museum

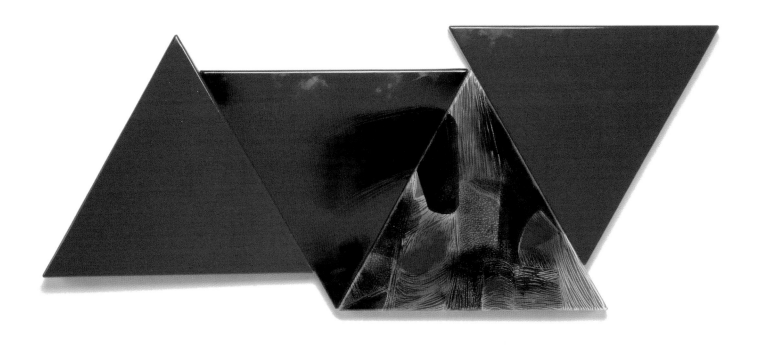

RED MUTATION

JoAnn Tanzer, b. 1926
1988
Vitreous enamel on steel
18 x 18″ (each panel)

Collection, Mingei International Museum

CABINET/ANTIBES

Wendy Maruyama
1992
Polychromed basswood
40 x 18 x 6¼″

Promised gift of Charmaine and Maurice Kaplan

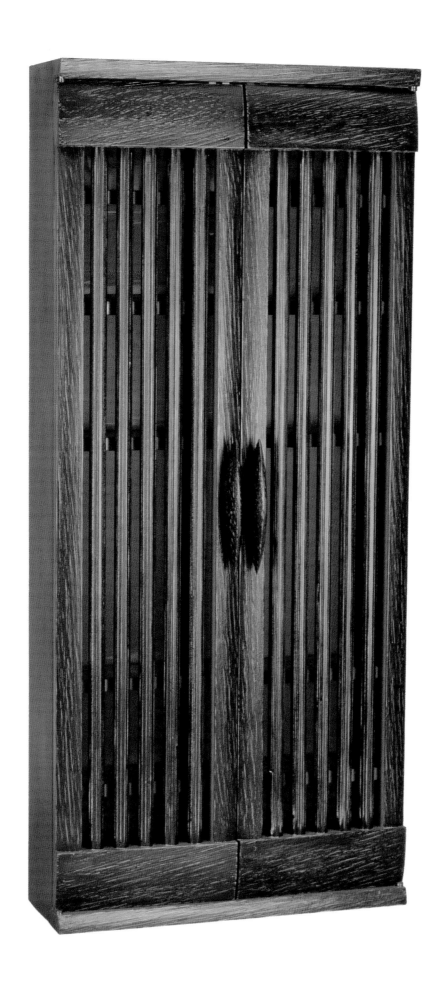

ULTRAMARINE SOFT CYLINDER WITH
BURNT ORANGE LIP WRAP

OPPOSITE

Dale Chihuly
Hand-blown glass
16½ x 14 x 15″

Promised gift of Charmaine and Maurice Kaplan

BROWN TRACERY/ROOM DIVIDER

PAGE 146

Eve Gulick, b. 1907
1957
Linen
114 x 37½″

Collection, Mingei International Museum

HOLLOW FORM

PAGE 147

Laura Andreson, b. 1902
1969
Lustre glazed porcelain
5⅛ x 5¼″

Collection, Mingei International Museum
Gift of Ruth Granstrom in memory of Evangeline LeBarron

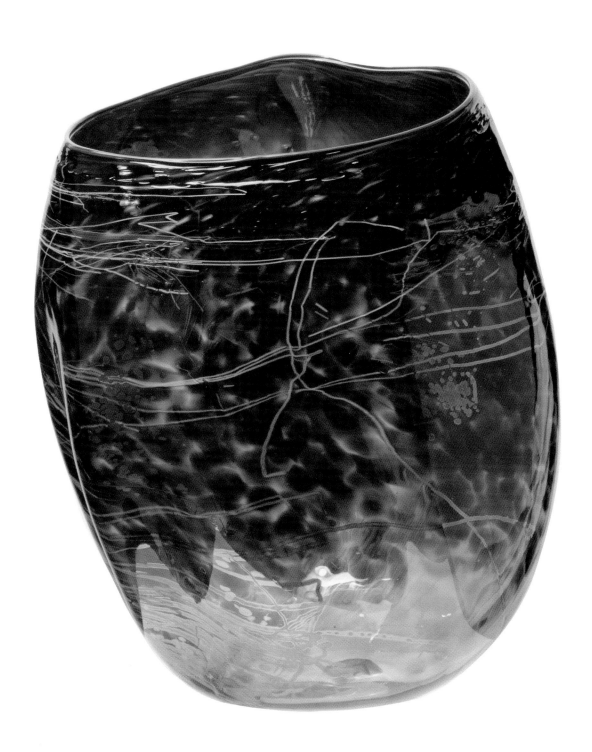

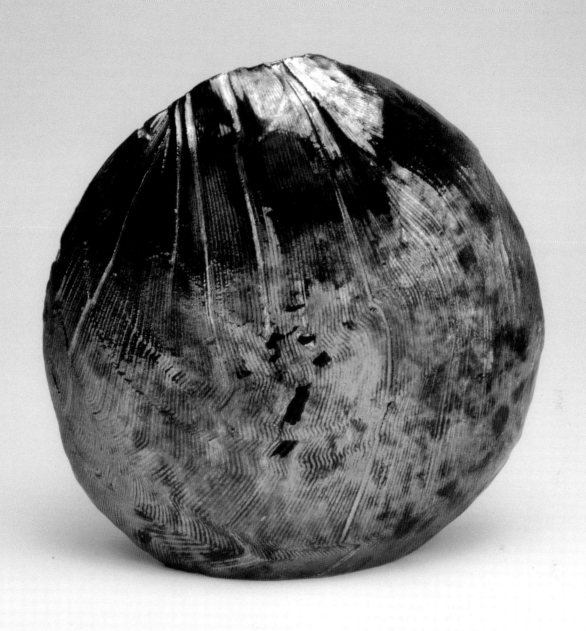

EMERALD BLUE LUSTRE BOTTLE

Beatrice Wood, b. 1893
1978
Ceramic
5⅝ x 2¾″

Collection, Mingei International Museum
Gift of Kevin Carey Settles and David VanGilder
Photograph by Julie Bubar

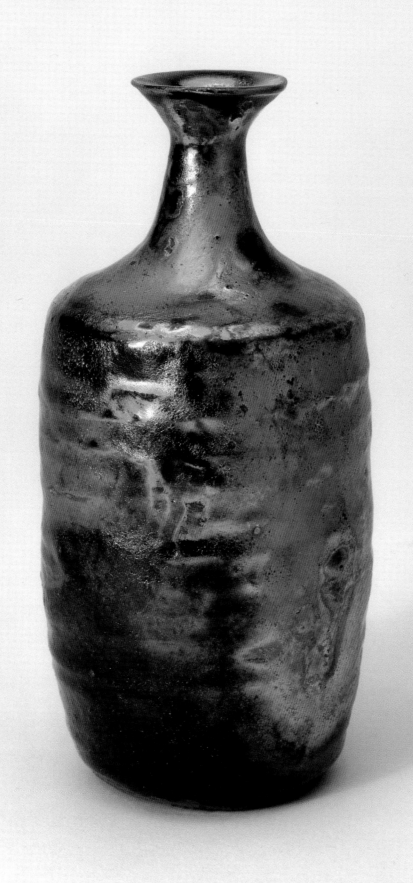

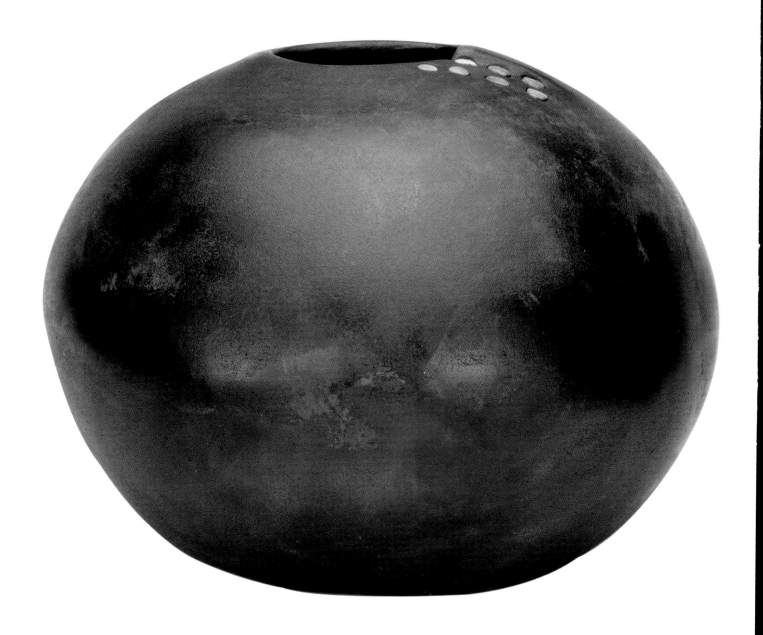

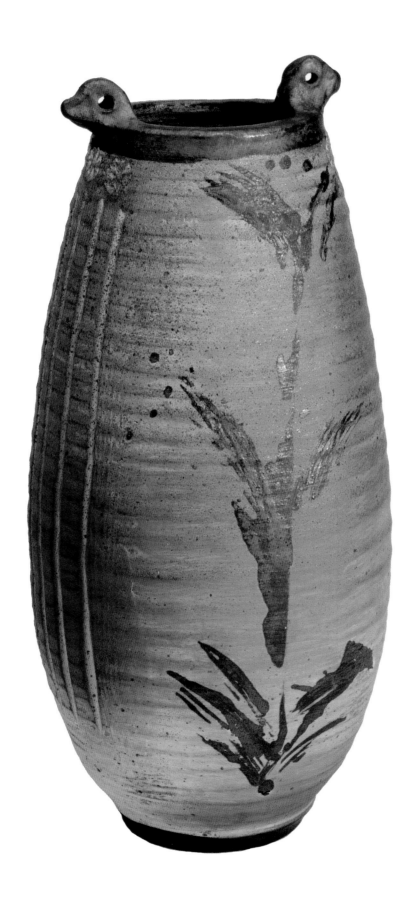

SEVEN TURQUOISE

PAGE 150

Ramona Rowley, b. 1945
1995–1996
Metallic pit fired clay
16 x 21½"

Collection, Mingei International Museum
Photograph by Julie Bubar

VASE

PAGE 151

Vivika Heino (1910–1995)
Otto Heino, b. 1915
Wood fired stoneware, 1995
13⅞ x 6⅝"

Collection, Mingei International Museum
Photograph by Julie Bubar

JAR WITH LID

OPPOSITE

Karen Karnes
1976
Salt glazed stoneware
16 x 11½" diam.

Collection, Mingei International Museum

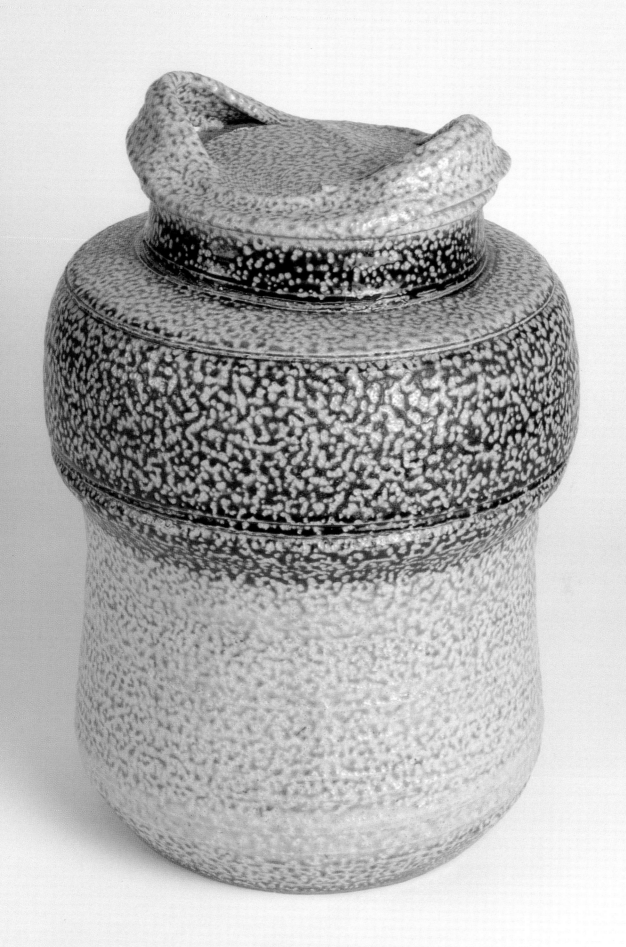

NATURAL ASH GLAZED POT

Martha Longenecker-Roth
1968
Stoneware
8 x 5⅛" diam.

Collection, Mingei International Museum

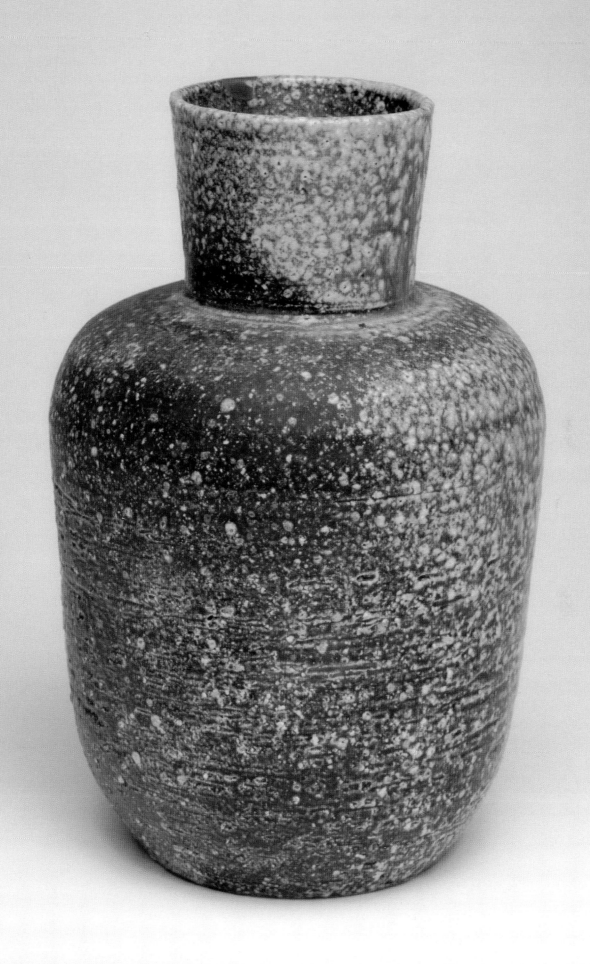

MENORAH     OPPOSITE

Otto Natzler
1977
Ceramic, ivory and sulphur-green crater glaze
$11\frac{3}{16}$ x $12\frac{1}{2}$ x $3\frac{1}{8}''$

Promised gift
Photograph by Julie Bubar

ROCKING CHAIR  PAGE 158

Sam Maloof
1996
Walnut with ebony
27 x 46 x 46"

Collection, Mingei International Museum
Photography by Gene Sasse

BENIN BROCADE/SAPPHIRE PAGE 159

Jack Lenor Larsen
Designed, 1962
Wool, nylon, rayon, silk
108 x 52"

Collection, Mingei International Museum

Jack Lenor Larsen Incorporated, founded in 1953 by its namesake, is today a dominant force in international fabrics and a major influence on environmental design. "The Larsen Look" began with handwoven fabrics of varied yarns in random repeats. Many of these won design awards. The years since read like a Who's Who of important commissions and works selected for the permanent collections of major museums.

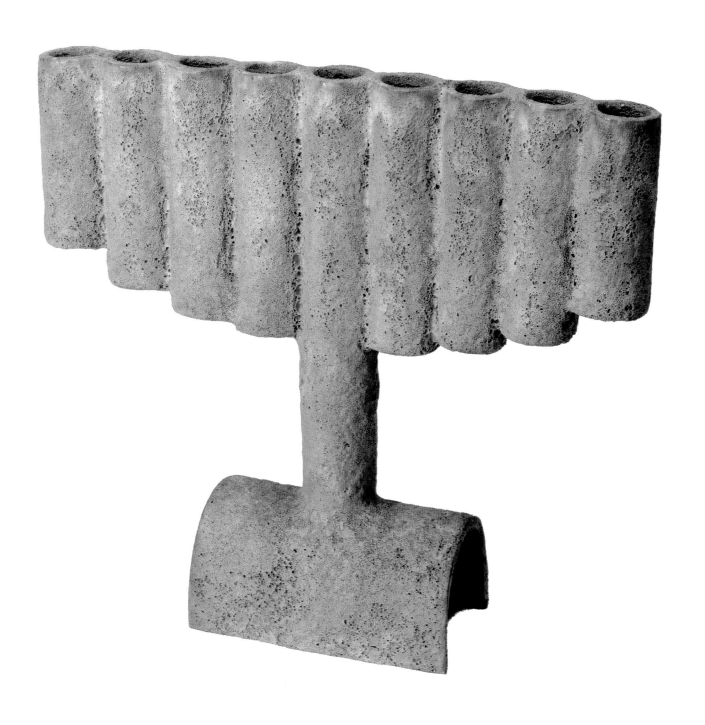

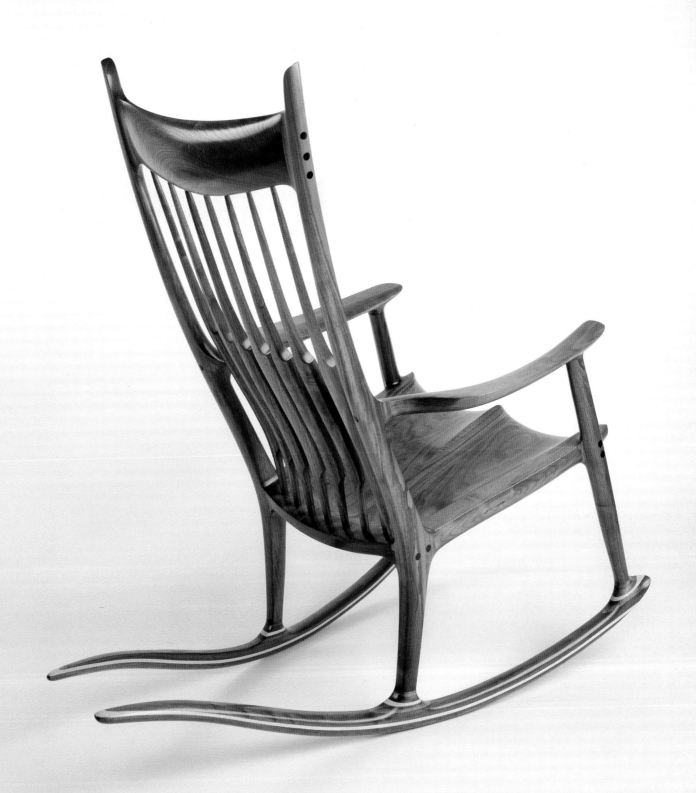

Related Readings

AMERICAN FOLK ART, EXPRESSIONS OF A NEW SPIRIT. New York: Museum of American Folk Art, 1982.

AMERICAN FOLK ART: THE ART OF THE COMMON MAN IN AMERICA, 1750–1900. New York: The Museum of Modern Art, 1932.

AMERICAN FOLK SCULPTURE: THE WORK OF EIGHTEENTH AND NINETEENTH CENTURY CRAFTSMEN. Newark, New Jersey: The Newark Museum, 1931.

Barrett, Didi. MUFFLED VOICES: FOLK ARTISTS IN CONTEMPORARY AMERICA. New York: Museum of American Folk Art, 1986.

Bishop, Robert and Carter Houck. ALL FLAGS FLYING: AMERICAN PATRIOTIC QUILTS AS EXPRESSIONS OF LIBERTY. New York: E.P. Dutton in association with the Museum of American Folk Art, New York, 1986.

Bishop, Robert and Jacqueline M. Atkins. FOLK ART IN AMERICAN LIFE. New York: Penguin Books USA, Inc., 1995.

Bishop, Robert. AMERICAN FOLK SCULPTURE. New York: E.P. Dutton & Company, Inc., 1974.

Cavigga, Margaret. AMERICAN ANTIQUE QUILTS. Japan: Shufunomoto Company, Ltd., 1981.

Chihuly, Dale. CHIHULY — FORM FROM FIRE. Seattle: The University of Washington Press in cooperation with The Museum of Arts and Sciences, Daytona Beach, Florida, 1993.

Cubbs, Joanne. THE GIFT OF JOSEPHUS FARMER. Milwaukee: Milwaukee Art History Gallery, University of Wisconsin, 1982.

Diamonstein, Barbaralee. HANDMADE IN AMERICA — CONVERSATIONS WITH FOURTEEN CRAFTMASTERS. Harry N. Abrams, Inc., New York, 1983, 1995.

Earnest, Adele. FOLK ART IN AMERICA: A PERSONAL VIEW. Exton, Pennsylvania, Schiffer Publishing, Ltd., 1984.

Elijah Pierce: WOODCARVER. Columbus, Ohio: Columbus Museum of Art, 1992.

Fagaly, William A. DAVID BUTLER. New Orleans: New Orleans Museum of Art, 1976.

Feder, Norman. AMERICAN INDIAN ART. New York: Harry N. Abrams, Inc., 1971.

Finster, Howard, as told to Tom Patterson. HOWARD FINSTER: STRANGER FROM ANOTHER WORLD: MAN OF VISIONS NOW ON THIS EARTH. New York: Abbeville Press, 1989.

Fox, Nancy Jo. LIBERTIES WITH LIBERTY: THE FASCINATING HISTORY OF AMERICA'S PROUDEST SYMBOL. New York: E.P. Dutton & Company, Inc. in association with the Museum of American Folk Art, New York, 1986.

Fraley, Tobin. THE GREAT AMERICAN CAROUSEL. San Francisco: Chronicle Books, 1984.

Fried, Fred. A PICTORIAL HISTORY OF THE CAROUSEL. New York: Bonanza Books, 1964.

Hall, Michael D., and Eugene W. Metcalf, Jr. THE ARTIST OUTSIDER: CREATIVITY AND THE BOUNDARIES OF CULTURE. Washington: Smithsonian Institution Press, 1994.

Hemphill, Herbert W., Jr., and Julia Weissman. TWENTIETH-CENTURY AMERICAN FOLK ART AND ARTISTS. New York: E.P. Dutton & Company, Inc., 1974.

Hemphill, Herbert W., Jr., ed. FOLK SCULPTURE U.S.A. New York: The Brooklyn Museum, 1976.

Herbst, Toby and Joel Kopp. THE FLAG IN AMERICAN INDIAN ART. Cooperstown, New York: New York State Historical Association, 1993.

Larsen, Jack Lenor with Betty Freudenheim. INERLACING, THE ELEMENTAL FABRIC. Tokyo: Kodansha International, Ltd., 1986.

Larsen, Jack Lenor, and Mildred Constantine. THE ART FABRIC: MAINSTREAM. Van Nostrand Reinhold, 1981.

Larsen, Jack Lenor, with Alfred Buhler, Bronwen and Garrett Solyom. THE DYERS ART. Van Nostrand Reinhold, 1976.

Lipman, Jean and Alice Winchester. THE FLOWERING OF AMERICAN FOLK ART. New York: The Viking Press in cooperation with the Whitney Museum of American Art, 1974.

Livingston, Jane, and John Beardsley. BLACK FOLK ART IN AMERICA, 1930–1980. Jackson: University Press of Mississippi, 1982.

Longenecker, Martha. LAURA ANDRESON. La Jolla, California. Mingei International Museum, 1982.

Luck, Barbara R., and Alexander Sackton. EDDIE ARNING: SELECTED DRAWINGS, 1964–1973. Williamsburg, Virginia: Colonial Williamsburg Foundation, 1985.

Maloof, Sam. WOODWORKER, Kodansha International USA, NY, 1983.

Metcalf, Eugene, and Michael Hall. THE TIES THAT BIND: FOLK ART IN CONTEMPORARY AMERICAN CULTURE. Cincinnati: Cincinnati Contemporary Arts Center, 1986.

Nakashima, George. THE SOUL OF A TREE. Kodansha International USA/NY, 1981.

Natzler, Otto. NATZLER CERAMICS. Los Angeles County Museum of Art, 1968.

Orlofsky, Patsy and Myron. QUILTS IN AMERICA. New York: Abbeville Press, 1974.

Pettit, Florence H. AMERICA'S INDIGO BLUES: RESIST-PRINTED AND DYED TEXTILES OF THE EIGHTEENTH CENTURY. New York: Hastings House, 1974.

Polley, Robert L., Editor. AMERICA'S FOLK ART: TREASURES OF AMERICAN FOLK ARTS AND CRAFTS IN DISTINGUISHED MUSEUMS AND COLLECTIONS. New York: G.P. Putnam's Sons, 1968.

Quimby, Ian M.G., and Scott T. Swank. PERSPECTIVES ON AMERICAN FOLK ART. New York: W.W. Norton & Company for the Henry Francis Winterthur Museum, 1980.

Rosenak, Chuck and Jan. CONTEMPORARY AMERICAN FOLK ART: A COLLECTOR'S GUIDE. New York: Abbeville Press, 1996.

Rosenak, Chuck and Jan. MUSEUM OF AMERICAN FOLK ART ENCYCLOPEDIA OF TWENTIETH-CENTURY AMERICAN FOLK ART AND ARTISTS. New York: Abbeville Press, 1990.

Rumford, Beatrix T., and Carolyn J. Weekley. TREASURES OF AMERICAN FOLK ART FROM THE ABBY ALDRICH ROCKEFELLER FOLK ART CENTER. Boston: Little Brown and Company, 1989.

Safford, Carleton L., and Robert Bishop. AMERICAN'S QUILTS AND COVERLETS. New York: E.P. Dutton & Company, Inc. 1972.

Sekimachi, Kay and Bob Stocksdale. MARRIAGE IN FORM. Palo Alto, CA: Palo Alto Cultural Center, 1993.

THE TACTILE VESSEL: NEW BASKET FORMS. Erie Art Museum, 1989.

Turner, J.F. Howard FINSTER: MAN OF VISIONS. New York: Alfred A. Knopf, 1989.

TWENTIETH CENTURY AMERICAN ICONS: JOHN PERATES. Cincinnati: Cincinnati Art Museum, 1974.

Warren, Elizabeth V. and Sharon L. Eisenstat. GLORIOUS AMERICAN QUILTS: THE QUILT COLLECTION OF THE MUSEUM OF AMERICAN FOLK ART. New York: Penguin Studio in association with the Museum of American Folk Art, 1996.

Weedon, Geoff. FAIRGROUND ART. New York: Abbeville Press, 1981.

Welsh, Peter C. AMERICAN FOLK ART, THE ART AND SPIRIT OF A PEOPLE. Washington D.C.: Smithsonian Institution, 1965.

162

International Advisory Board

Corporate Associates

Rice Hall James and Associates

Junckers Hardwood, Inc.

SmithBarney

TravelersGroup

Union Bank

Theodore W. Batterman Family Foundation

Director's Circle

CHARMAINE and MAURICE KAPLAN, Chairmen

Mr. Berle H. Adams

Dr. Bernard W. Aginsky

Mrs. Frances M. Armstrong

Barbara Baehr

Mr. and Mrs. Bob Baker

Mr. and Mrs. Charles Ballinger

Carolyn L. E. Benesh and Robert K. Liu

Dr. and Mrs. John Bergan

Mr. Norman Blachford

Mr. and Mrs. Roy K. Black

Mrs. Sook Bower

Ms. Judith Brucker

Mrs. Betty Upham Buffum

Patricia C. Dwinnell Butler

Mr. Richard A. Caras

Mr. and Mrs. Hugh Carter

Mr. and Mrs. Dallas Clark

Mr. and Mrs. Jacques Clerk

Mr. Kelly C. Cole, Neiman Marcus

Mr. David Copley

Mrs. Helen K. Copley

Dr. Roger C. Cornell

Mr. and Mrs. Donald Craib

Dr. Susan Crutchfield

Mr. and Mrs. Marc H. Cummings

Mr. and Mrs. Lawrence M. Cushman

Mr. and Mrs. Alex De Bakcsy

Mr. and Mrs. W. M. de Haan

Mr. and Mrs. Michael Dessent

Sally and Roy Drachman

Dr. and Mrs. Charles C. Edwards

Mr. Greg Farnsworth

Mr. Walter Fitch, III

Mr. and Mrs. J.L. Fritzenkotter

Mrs. Audrey Geisel

Mr. and Mrs. Edward Glazer

Mrs. Connie Golden

Dr. and Mrs. Hugh Greenway

Mrs. Ernest W. Hahn

Mr. and Mrs. Bruce Heap

Mr. and Mrs. Richard Helmstetter

Mr. William Heyler

Mr. and Mrs. Kenneth Hill

Mrs. Joan Holter

Mr. Theodore P. Hurwitz

Mrs. Louisa Kassler

Mr. Maurice M. Kawashima

Mr. and Mrs. Benjamin Kelts

Mr. and Mrs. Charles G. King

Mr. and Mrs. Frederick Kleinbub

Mrs. Helen W. Korman

Mr. Jack Kraus

Mr. Armand Labbé

Mr. and Mrs. George Lazarnick

Dr. and Mrs. Don Leiffer

Dr. Stefan Max

Lani and Herb McCoy

Mr. Tim Mertel and Mr. Alan Pate

Mr. and Mrs. James Mulvaney

Mrs. Dorothy D. Munro

William and Shirle O'Conner

Mr. and Mrs. George M. Pardee Jr.

Mrs. Jane Paull

Dr. and Mrs. Stanford S. Penner

Mrs. Betty Jo Petersen

Diane Powers

Mr. and Mrs. Sol Price

Mr. Elliott Rabin

Ms. Elizabeth Riis

Miss Claire Roach and

Mrs. Dorothy D. Roach

Mr. and Mrs. Charlie Robins

RADM and Mrs. W. Haley Rogers

John J. Safarik

Niki de Saint Phalle

Mr. and Mrs. Sam Scharaga

Mr. Hans W. Schoepflin

Mr. and Mrs. Victor Sell

Mrs. Priscilla Sellman

Dr. and Mrs. Greg Semerdjian

Donald and Darlene Shiley

Guy Showley and Jo Bobbie Mac Connell

Dr. Robert Singer and Ms. Judith Harris

Mr. Bradley Smith

Mr. Ed Smith

Mr. Russ Smith

Mr. Don Speer

Mr. and Mrs. Worley W. Stewart

Florence Temko and Henry Petzal

Ron and Mary Taylor

Mr. and Mrs. Horton Telford

Dr. and Mrs. Kenneth Trefftzs

Mr. and Mrs. Sam Trozzo

Mr. and Mrs. Roy Turney

Barbara Walbridge

John and Christy Walton

Mr. and Mrs. Frank Warren

Mr. and Mrs. Louis Weinstock

George F. Wick

Mr. and Mrs. Albert N. Williams

Mr. and Mrs. Harold B. Williams

Dr. Richard P. Wunder

Mr. and Mrs. Walter J. Zable

Patrons

Mrs. Willoughby Bishop

Mrs. Althea M. Brimm

John and Nancy Craig

Dr. and Mrs. Kirk J. David

Philip D. Davidson

Bonnie Roche

Mrs. Jack Farris

Mrs. Milton D. Goldberg

Mrs. Burton I. Jones

Mrs. Douglas Peacher

Miss Marion C. Pfund

Mr. Tatsuzo Shimaoka

Mr. and Mrs. Bob Sinclair

Deborah Szekely

HISTORY

- MINGEI INTERNATIONAL, incorporated in 1974, is a nonprofit public foundation for furthering the understanding of arts of people from all countries of the world. These arts share a direct simplicity and joy in making, by hand, useful articles that are satisfying to the human spirit.

- Mingei is a special word increasingly used throughout the world for "arts of the people." It was coined by the revered scholar, Dr. Soetsu Yanagi, through combining the Japanese words for all people *(min)* and art *(gei)*. His teachings awakened people to their essential need to make and use in their daily lives objects which are unfragmented expressions of body, mind and spirit.

- The Founder and Director of MINGEI INTERNATIONAL is Martha Longenecker, Professor of Art Emeritus, San Diego State University, who studied in Japan and was acquainted with the founders and leaders of the Mingei Association of Japan. They inspired her to carry this world vision to the United States.

- In 1976 two hundred members joined the foundation which operated as a "museum without walls."

- In 1977 MINGEI INTERNATIONAL was challenged by an unprecedented gift from University Towne Centre and Ernest W. Hahn and Associates of a twenty-year leasehold on shell building space — provided this young organization could design, build out and operate the Museum. The challenge was met, and Mingei International Museum of World Folk Art opened with a premier exhibition at University Towne Centre, San Diego, California on May 5, 1978.

- In 1986, the American Association of Museums awarded Mingei International full accreditation — tangible confirmation

of the Museum's excellence and recognition by other institutions, private foundations and governmental agencies.

- In its first eighteen years MINGEI INTERNATIONAL MUSEUM organized and presented sixty-two major exhibitions, some of which travelled to other museums throughout the nation. These exhibitions are enriched by an active educational program including related illustrated lectures, films, music and dance. They are supplemented by an international reference library of books, films, videotapes and photographs,

- Nineteen exhibition documentary publications have been produced and distributed to libraries and museums throughout the world,. The most recent , KINDRED SPIRITS — The Eloquence of Function in American Shaker and Japanese Arts of Daily Life, received a first prize in the American Association of Museum's national competition, 1996.

- The Museum's rapidly growing permanent collection now numbers more than 8,500 art objects from seventy-eight countries.

The exhibition AMERICAN EXPRESSIONS OF LIBERTY, inaugurates the Museum's new 41,000 square-foot facility on the Central Plaza of Balboa Park, San Diego, California.

The exterior of the new building (the historic House of Charm) was reconstructed by the City of San Diego. The architect for Mingei International's interior was David Rinehart, Design Principal for Anshen + Allen Architects and Planners. General building contractor was Soltek of San Diego.

MINGEI INTERNATIONAL is supported by memberships, volunteer services and tax deductible donations. Membership is open to all those interested in furthering the understanding of arts of people from all cultures of the world. 439 El Prado, San Diego, CA 92101, (619) 239-0003.

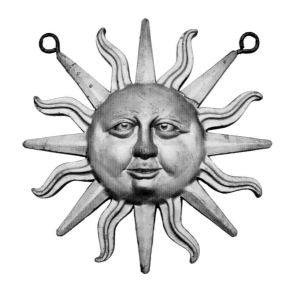

Museum Staff

MARTHA W. LONGENECKER	Director
ROB SIDNER	Assistant Director
CAROL Z. KLICH	Executive Secretary / Operations Manager
MARTHA EHRINGER	Director of Public Relations
JOHN P. DIGESARE	Registrar
JAKE HARSHBARGER	Archivist / Assistant to the Registrar
CHRISTEN E. RUNGE	Secretary
CHARLES J. ANDRICCI	Security
BRYAN J. LOYCE	Security
KALMAN MAKLARY	Exhibition Preparator
SUE ANN DALEY-MATHIEU	Collector's Gallery Manager–U.T.C.
ANN V. PEDICORD	Collector's Gallery Assistant

VOLUNTEER STAFF

NANCY J. ANDREWS	Librarian
EILEEN MILLER	Receptions Coordinator
V'ANN CORNELIUS	Docent Coordinator
BILLIE SUTHERLAND	Secretary

PUBLICATION

DESIGN AND EDITING	Martha W. Longenecker
EDITING ASSISTANT	Rob Sidner
PRODUCTION ASSISTANT	Martha Ehringer
PRODUCTION LIAISON	Frederick W. Dick
TYPESETTING	Barbara Ryan
PREPRESS AND PRINTING	Arizona Lithographers

Printed on Mead Signature ® Satin #100 Book, distributed by Zellerbach, a Mead Co.

SUN SHOP SIGN Artist unknown 19th century Metal and gold leaf 21½ x 21½"

Collection, Margaret and Bill Pearson